Kama Sutra

'A good lover has to be sensitive to a woman's needs.' Pavan K. Varma's new-age adaptation of Vatsyayana's cult classic *Kama Sutra* makes precisely this point. Keeping in mind the celebrated sage's instruction that men and women are equal partners in the act of consummation, Varma takes us on a witty journey through what has sometimes been seen as a 'heavy' manual on sex, and at others as a volume of titillating visuals. This adaptation is a serious tribute to the genius and vision of Vatsyayana, highlighting the 'modernity' of what he wrote two thousand years ago – that the fulfilment of women is at the heart of the experience of sex, and that the lines between sex and sensuality, and between social mores and individual desire are indeed fine and must be understood deeply.

Writer-diplomat *Pavan K. Varma*, born in 1953, is a graduate in History from St. Stephen's College, New Delhi. He joined the IFS in 1976. He has been press secretary to the President of India, spokesman of the ministry of external affairs, high commissioner for India in Cyprus, director of The Nehru Centre, London, and director general of the ICCR, New Delhi. Author of more than a dozen books, his first book on a contemporary subject was the path-breaking *The Great Indian Middle Class*, followed by *Being Indian: The Truth About Why the 21st Century Will Be India's*, later published by William Heinemann in the United Kingdom and translated into Japanese, Spanish, French, and Portuguese. A widely admired public speaker, Pavan Varma was conferred an Honorary Doctoral degree for his contribution to the field of diplomacy, literature, culture, and aesthetics by the University of Indianopolis.

ISBN: 978-81-7436-448-7

© This edition Roli Books Pvt. Ltd., 2019
Sixth impression
Published in India by Roli Books
M-75, Greater Kailash-II Market
New Delhi-110 048, India
Ph.: ++91-11-4068 2000
Email: info@rolibooks.com
Website: www.rolibooks.com

Printed and bound in Sundeep Press

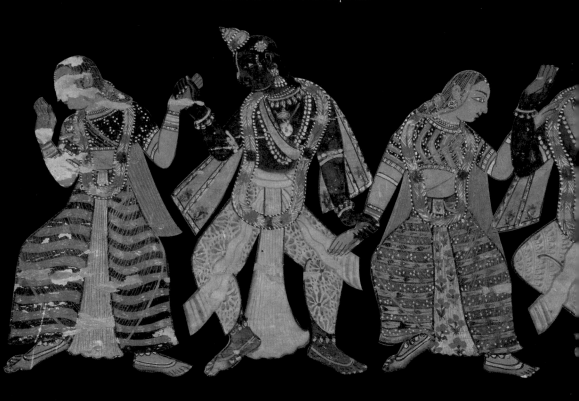

Kama Sutra

the art of making love to a woman

Pavan K. Varma

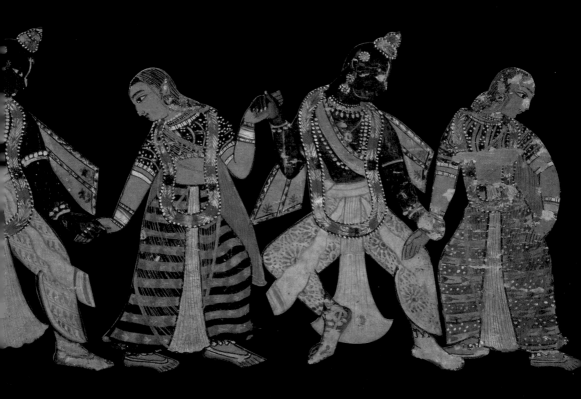

Lustre Press
Roli Books

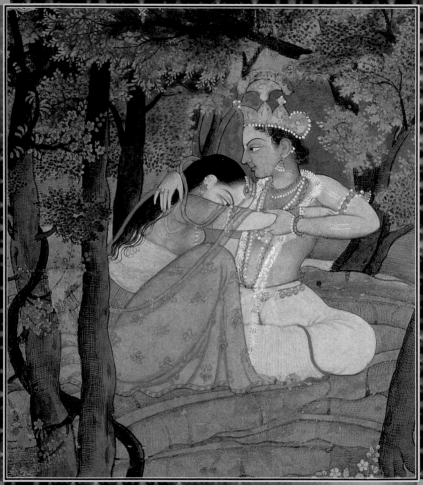

Contents

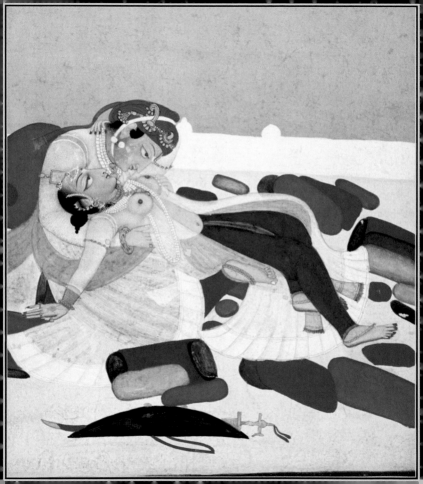

Introduction

*T*he purpose of this book is to draw attention to, and try to remedy, a problem of the most distressing proportions of our times: the demise of the erotic sentiment. This may seem odd when never before in the history of mankind has there been so much prominence and social sanction accorded to the practice of sex. Sex is everywhere: on billboards, on television, in newspapers, in magazines, in books, in films, and in the vast domain of cyberspace. The problem lies precisely in this surfeit. There is so much about sex in our routine existence that we have forgotten what it is all about!

The degree of ignorance appears to be in direct proportion to the exposure. Men who claim to be great lovers are usually the most ignorant. They know a lot about how to please themselves during sex, but not nearly enough about how to please those who are the source of that pleasure: women. This is nothing short of a catastrophe in an age when many women

have finally begun to discover their sexuality, and want the optimum out of sex, without inhibitions or guilt.

What can be done to change this situation? Must women be condemned to search forever for the fulfilling sexual experience, while men think they know everything there is to be learnt about sex? Or, can men be jolted out of this false complacency, and begin to see sex as a celebration where technique matters, but the approach and the attitude, the mood and the sentiment, play an equally – if not more – important role?

The sage Vatsyayana, who wrote the celebrated *Kama Sutra* nearly two thousand years ago, is the *nabob* of the erotic mood. It is terribly inaccurate to identify him only with the technique of making love. Somehow the notion has got around that he was some kind of gymnast, who took sadistic pleasure in proposing the most impossible postures, which only a clever contortionist could practise. Men are the first to misunderstand him. They are so taken up with technique that they do him – and themselves, and, of course, women – the great disservice of reducing sex to a mechanical act of friction.

Vatsyayana is all for good technique, but he believes that good sex is more than just that. Good sex requires men to do more than just ooze

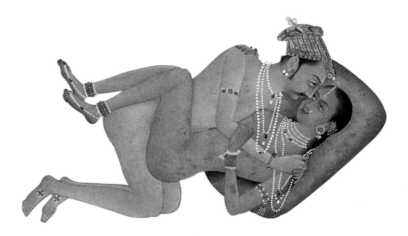

testosterone. A good lover has to be sensitive to a woman's needs, and Vatsyayana puts the fulfilment of women at the heart of the cosmic experience of sex. Their demands, their responses, the things that arouse them, and their climax get primacy.

Modern men (if there is a species like that) may be willing to accept that women are equal partners in the pleasures of sex, but very few men are willing to accept that women can be different in their expectations of good sex. Men have more than a sneaking suspicion that women enjoy it more. They know that women can enjoy it longer. What they need to understand is that women may have different definitions of sensual fulfilment, and their own personally coded paths to sexual arousal; and understand also that women suffer when their partners see them only as objects of their short-lived desires. The *Kama Sutra* is the votary of the intelligent lover who is willing to invest in what is conducive to a woman's satisfaction.

Vatsyayana enjoins men to respect the sensuality of women. His constant exhortation is that a man should do what a woman enjoys. He should interpret her needs and understand her preferences. For the act of making love to be truly fulfilling for both partners, it requires the 'application of the proper means.' A 'quick encounter' can be satisfying in its own way. However, the *Kama Sutra* is more preoccupied with sex with a capital S, where a man tantalisingly leads a woman from the base of his desires to the pinnacle of her fulfilment; here, it is a languorous, drawn-out affair, involving dalliance and foreplay and the slow simmer of passion, until the explosive culmination, and its post-coital afterglow. No detail in this journey is too small: the place, the setting, the embrace, the kiss, the use of nails, the bite, the use of force and, of course, the act itself.

A man needs to prepare himself to fully enjoy the sensual experience. A good lover must develop those aspects of his personality that are pleasing to women. It is possible for all men to acquire skills that enhance their appeal to women. Men should make the effort to do so. Indeed, according to Vatsyayana, a man is not cultured enough if he does not wish to be an accomplished lover. Lovers who come to the altar of sensuality without

knowing the rituals of the service, or the language of her fulfilment, are boors who are also missing out on a lot of fun.

The ancient Indian approach to sex may be a little out of sync with the casual approach of modern times, but the old sages were no prudes. Their goal was the maximisation of pleasure, and they were quite beyond any silly notions of morality. However, they treated desire with respect, and urged men to become worthy of that exalted emotion by treating the needs of women with deference. In doing so they did not wish men to become self-denying altruists. Their rationale was that only by giving a woman what she wants does a man receive, in the fullest measure, what he wants himself. He worships desire, as much to fulfil as to be fulfilled.

Hopefully, the erotic wisdom of India can help salvage the sensual from the avalanche of flesh around us. Women have the right to more sensitive lovers, and men have the ability to turn into just that. The sexual experience is one of the most beautiful gifts of God. And both men and women must learn to optimise that gift, in a manner that leaves them suffused with gratitude. This is the simple message of this book.

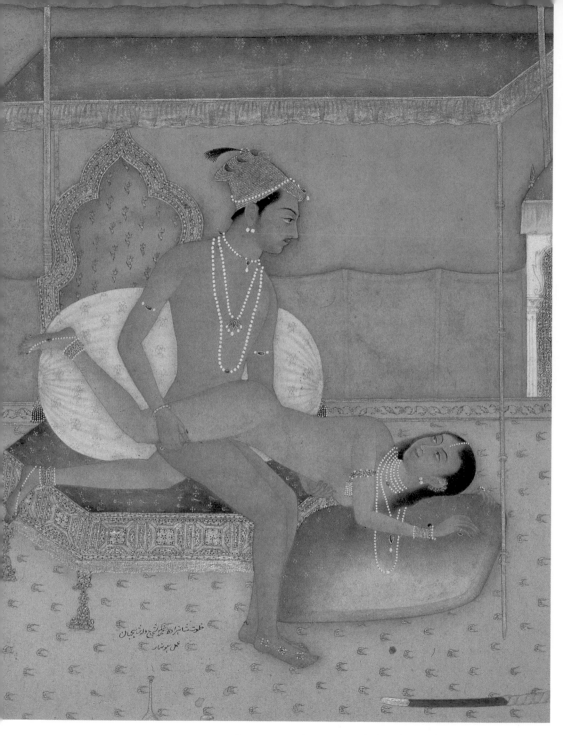

Innovation and variety are the key elements to keep the passion alive.

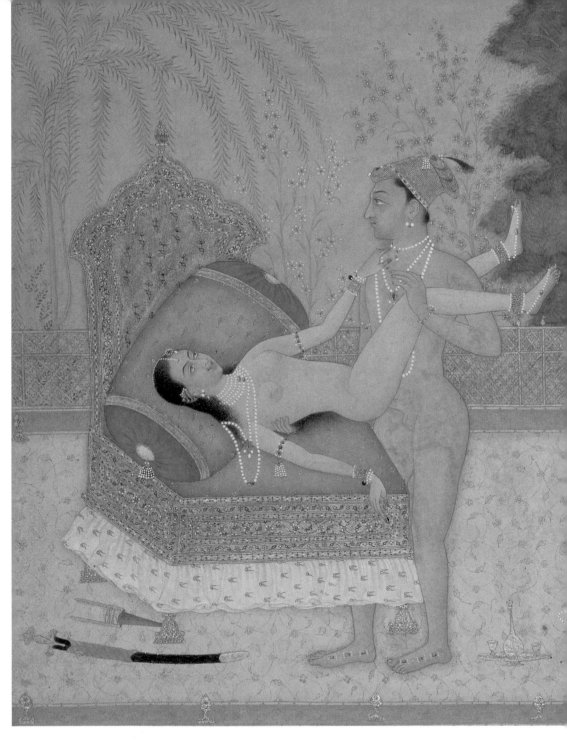

A man should read a woman's reactions in order to give her greater pleasure.

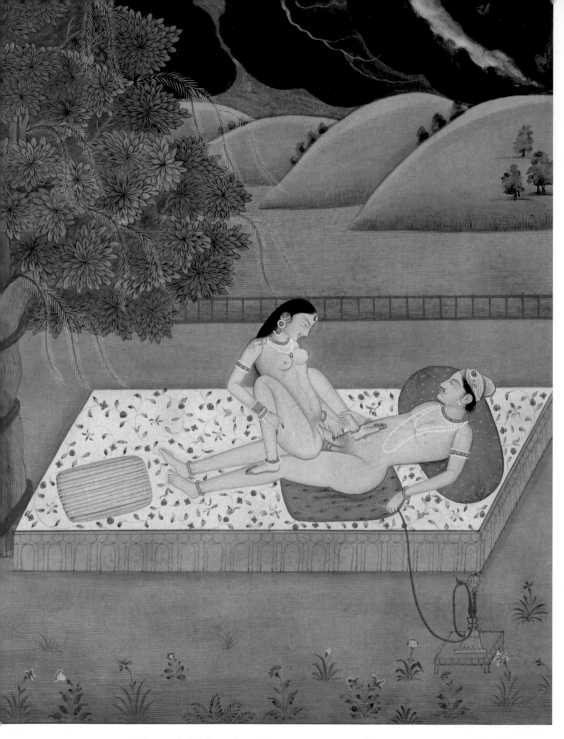

Nothing is forbidden in love. Vatsyayana encourages lovers to experiment and be adventurous.

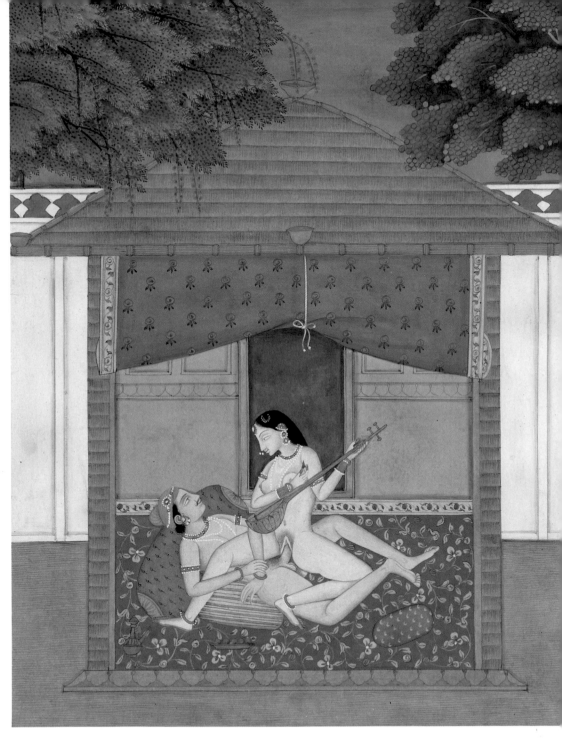

Not only does music set the mood, but it also helps lovers reach new heights of pleasure.

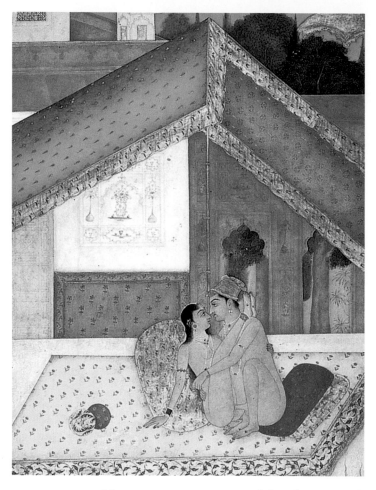

Maintaining eye contact creates a feeling of intimacy and, thus, stimulates passion.

Facing page: *Whatever the setting, the man has to initiate the woman in the art of making love.*

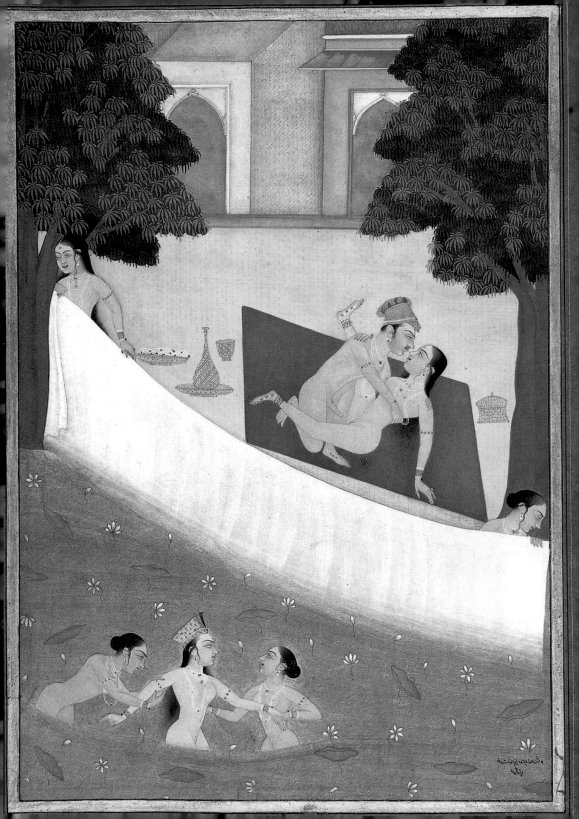

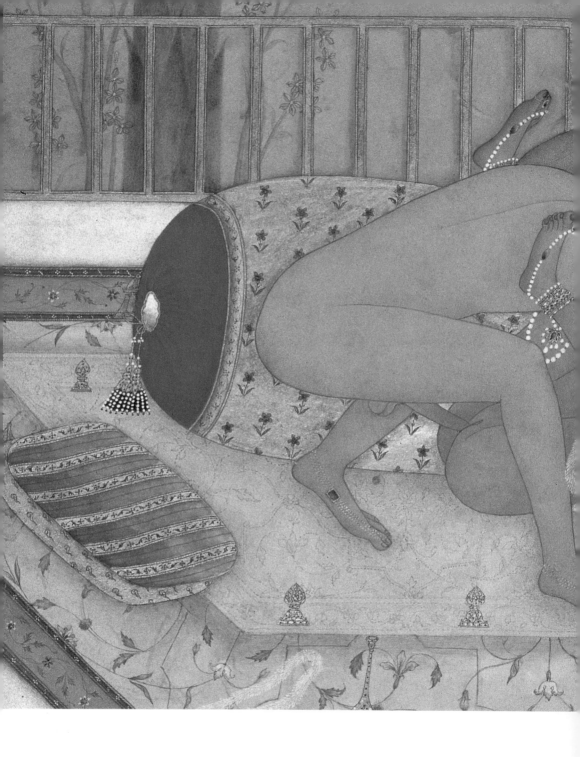

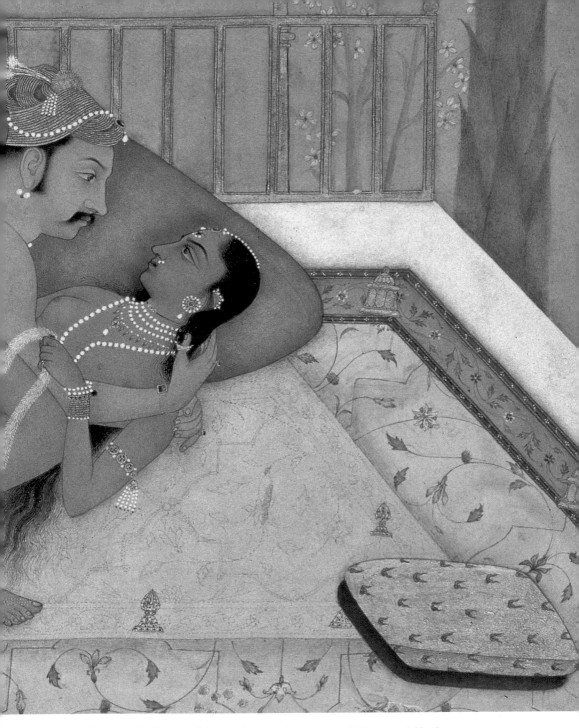

Courtesans had mastered the art of making love and they held a respectable place in society.

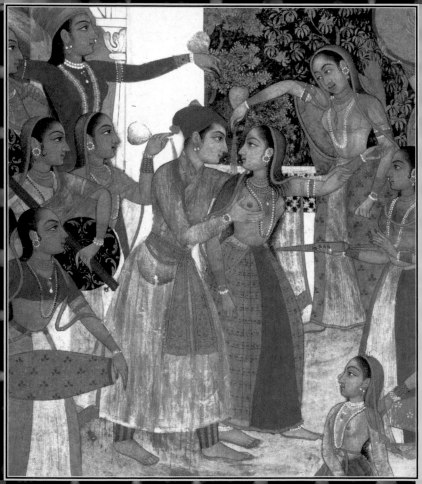

Why Desire
is Desirable

*M*any people do not know that India's ancient manuals on the art of making love have been written not by some sex-obsessed maniacs determined to give their premature formula to others, but by venerable sages who combined prayer with promiscuity in such effortless harmony that they remained erect in prayer, and prayerful in their erections. According to lore, it was Prajapati, the Creator, who first delved into this subject of pleasure when he sought to formulate a code of conduct for the social life of his uncontrollable progeny. This was followed by a procession of sages who focused with increasing intensity on the most enjoyable part of this code: sex. Thus, Nandikeshwara, who was otherwise absorbed in meditating on Shiva, culled out a thousand chapters on the rules that should govern the complex business of fornication. Svetaketu Aruni distilled these into half the number; then the hoary sex specialist Babhravya, reversing the usual preoccupation of his species with size, reduced the inflammable material to

one hundred and fifty chapters. Finally, seven *pundits*, renowned for their spiritual learning, divided the corpus into seven seminal works, dealing with matters of communion such as sexual congress, the art of seducing the wives of others, the attributes of a prostitute, aphrodisiacs and sexual aids. Many hundreds of years later, in the third century AD, the redoubtable Vatsyayana wrote a readable compendium based on these writings and called it *Kama Sutra*.

Sex has, therefore, been a matter of high priority for Indians for over two thousand years – proof of its staying power, if not the performing ability of its practitioners. Vatsyayana was also called *mahamuni*, or 'great saint'. His masterpiece, the *Kama Sutra*, has been described by the discerning as 'immortal', possibly because some of the postures it recommends are quite beyond a mortal's capabilities. It is said that the great saint remained celibate by choice for a full year prior to writing his magnum opus. This would explain the natural correlation between deprivation and desire, since many scholars feel that it is written with a great deal of suppressed passion.

Not too much is known about the physical prowess of the sex guru, but a number of *mahamunis* were known to sport a powerful physique, with ample opportunity for the doubtful to verify their endowments since they wore little more than a tightly bound loincloth. The ability of the great sage to abstain from sex for as long as a year would certainly be difficult for most Indian men to emulate. Indians are as preoccupied with sex as anyone, but they love to project an image that places them high-mindedly above it. Perhaps their inclination towards the sensual is so irrepressible that they need the assertion of spiritual asceticism as a counterfoil. In any case, Hindu mythology is full of evidence of the uncontrollable sexual appetites of many well-known sages. The fact is that their principal vocation to strive for spiritual salvation never prevented them from being aroused by women. When they lusted, they were like rogue elephants in rut, capable of throwing all discretion to the winds in order to fulfil their passions. In fact, their gods were no better. Indra, the supreme warrior god and the Indian counterpart of Olympus, was unrepentant in his attempts to seduce the wives of other

men, and often did so very sneakily by assuming the form of their husbands, so that his victims were right when they described their experience as divine. His wife, Indrani, must have been occasionally put off by his extra-curricular activities, and his inabilities to replicate them at home, for in the *Rig Veda*, one of Hinduism's most revered scriptures, she rebukes him thus:

> *He achieves not – he whose penis hangs limp between the thighs*
> *Achieves he alone whose hairy thing swells up when he lies*
> (*The Continent of Circe* by Nirad C. Chaudhury)

Other divine luminaries could be equally impassioned. Brahma is said to have lusted after Parvati even as he was conducting her marriage with Shiva. The *Bhavisya Purana* recounts that the venerable trinity – Brahma, Vishnu and Shiva – once saw Lord Atri, son of Prajapati, sitting on the banks of the Ganga with his wife Anasuya. Atri was absorbed in meditation, so the three divinities approached Anasuya and were at once consumed by desire for her. Brahma said: 'Grant me sexual pleasure, or I will abandon my life's breath, for you have caused me to whirl about drunk with passion.' When Anasuya resisted their advances, they collectively attempted to force her into submission, until Anasuya stopped them with a curse.

The intrepid lady was absolutely right in cursing the besotted gods, but she must have known, of course, that Kama, the god of love, akin to the Greek Eros, or the Roman Cupid or Amor, had always been a respected part of the Hindu pantheon. The *Atharva Veda* exalted him as a supreme god and creator. 'Kama was born the first. Him neither gods, nor fathers, nor men have equalled.' The *Rig Veda* pays similar homage, commending him for worship since he is unequalled by the gods. 'May Kama, having well directed the arrow, which is winged with pain, barbed with longing, and has desire for its shaft, pierce thee in the heart.' According to Hindu mythology, it was only Kama who could distract that great *tapasvi* Shiva from his deep meditation by arousing in him amorous thoughts of Parvati. The story goes that Shiva, angered by the disruption in his meditation, burnt Kama to ashes.

He then asked Parvati to ask for a boon and she answered: 'Now that Kama has been killed, what can I do with a boon from you? For without Kama there can be between man and woman no emotion that is like ten million suns.' Shiva repeated his request and Parvati asked that Kama be brought to life again to heat the world. And so Kama was reborn.

It will, thus, be perfectly clear that the hermitages of ancient India were far from being centres only for the practice of chastity. Vatsyayana, and the seven sages who preceded him, were worthy representatives of this lineage. Still, what sets our *mahamuni* apart was the cerebral vibrancy he brought to the practice and pursuit of desire. The *Kama Sutra* opens not with a graphic description of a posture, as most would imagine, but with a cool, dispassionate and reasoned contemplation on the legitimacy of desire. There are four goals that should animate the intelligent man, argues Vatsyayana. The first three are *Dharma*, or right conduct; *Artha,* or the acquisition of wealth; and *Kama,* or the pursuit of desire. If *Dharma*, *Artha* and *Kama* are

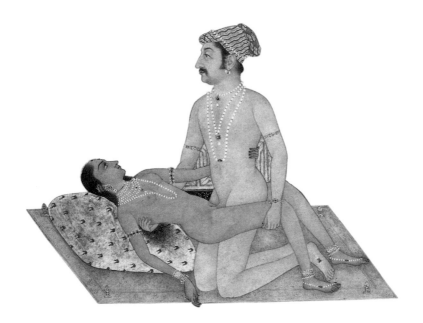

pursued in proportion, as the manifestations of a balanced life, then *Moksha* or salvation, the fourth and final goal, is the natural consequence.

Vatsyayana did not stop at just stating a general proposition. In elevating *Kama* so boldly as one of the four *purusharthas*, or goals of life, he knew he would be inviting objections from the envious and the righteous. He, therefore, set out to address their objections. The first of these was that pleasures of the flesh bring ruination. Caught in the swirl of passion, a person forgets the difference between right and wrong. He loses his sense of discrimination, and becomes incapable of safeguarding his material well-being. Why should *Kama* be included at all in the acceptable trinity of *Dharma*, *Artha* and *Moksha*?

For very good reasons, retorts our ancient *muni*. Like food, pleasures help sustain the body, and must be given their due importance. In fact, pleasures are the valid rewards of the successful pursuit of *Dharma* and *Artha*, which in plain language means that a good man has deserved his moral indiscretions and a rich man can well afford them. As for the danger of going overboard, Vatsyayana does emphasise the need for moderation. Yet, no one stops driving a car because accidents take place, or to use his analogy, no one stops cooking food because beggars may ask for it, or stops sowing seeds because there are animals to destroy the harvest.

The second objection was more devious. Even if the existence of desire is acknowledged, what is the need to dilate at such length on its practice and performance, since it is based on instinct, and even members of the animal kingdom can be seen responding to it without a manual in their hands? In answering this, our good sage rightly draws a distinction between men, women and animals. In the animal world, he says, females are fit for intercourse only in certain seasons, and coitus is not preceded by thought of any kind. On the other hand, sexual intercourse between a man and a woman is not simply a matter of basic instinct. It requires, he says, application of the proper means.

With his premises as foundation, Vatsyayana's lasting contribution was to build an approach and an action plan that would guarantee the optimum

use of desire. How did he do that? Firstly, as we have seen, he proclaimed that desire is desirable. He did so not on the basis of religious scripture, or only because of the hormones stirring within him after a prolonged period of abstinence, but on the strength of logic. Secondly, in exalting desire without inhibition or doubt, he liberated forever the sexual impulse from any notion of guilt. To want to do it was not something to be ashamed of. Desire was not to be relegated to dark corners. On the contrary, it was something to be celebrated, as one of the resplendent goals of life, blessed by the gods, a path to *moksha*, and a source of joy and indescribable fulfilment. Sex could be a window to the Divine. Divinity could be glimpsed in the joyous explosion of an orgasm. The sacred and the profane were two sides of the same coin. Both were valid aspects of the complete and balanced life. The guru had little time for a man unconvinced about the resplendence of his sensual desires, or rendered flaccid by an undesirable sense of guilt. In the erotic temple in which he worshipped, only a believer, joyously liberated from the debilitating doubts of the mind about right and wrong, shame and regret, and suchlike, could enter.

If the pursuit of desire is one of the most important goals of life, then it is not enough, Vatsyayana argues, to be merely any kind of lover. One must be an accomplished lover. A man who merely uses a woman for an uncontrollably brief moment of physical friction, giving unilateral satisfaction to himself, is undesirable, ignorant of his own potential, and callous towards such a great gift of the gods. To put it bluntly, such a man is uncultured.

Yet, he is not beyond redemption. Through the application of the proper means each man has it within himself to become a good lover, considerate and sensitive to a woman's needs, and capable of driving her to ecstasy and fulfilment. In the chapters that follow, we will walk along with our revered sage and discover how exactly this can be made possible.

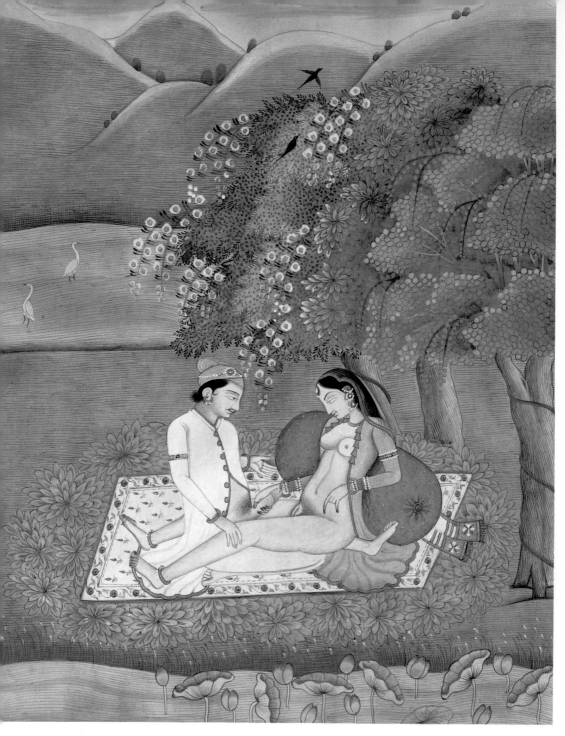

There is one yoni and one lingam, but the two can join in a myriad ways.

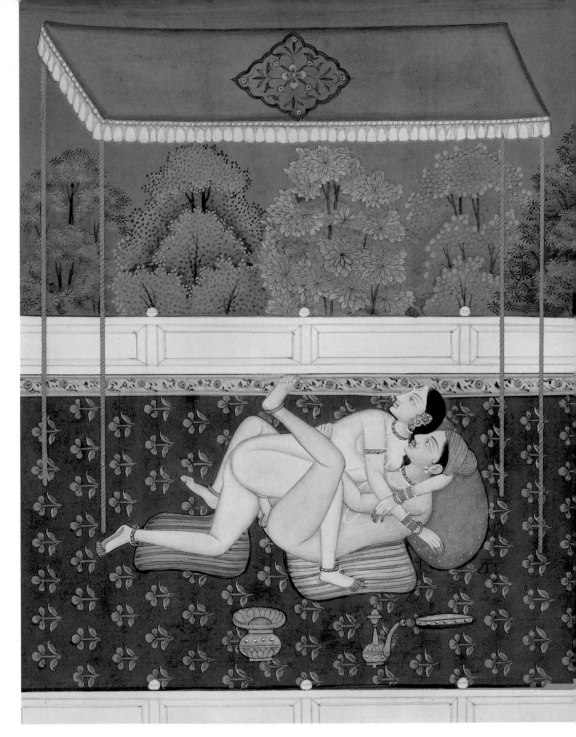

Women experience sexual pleasure in as intense a way as men.

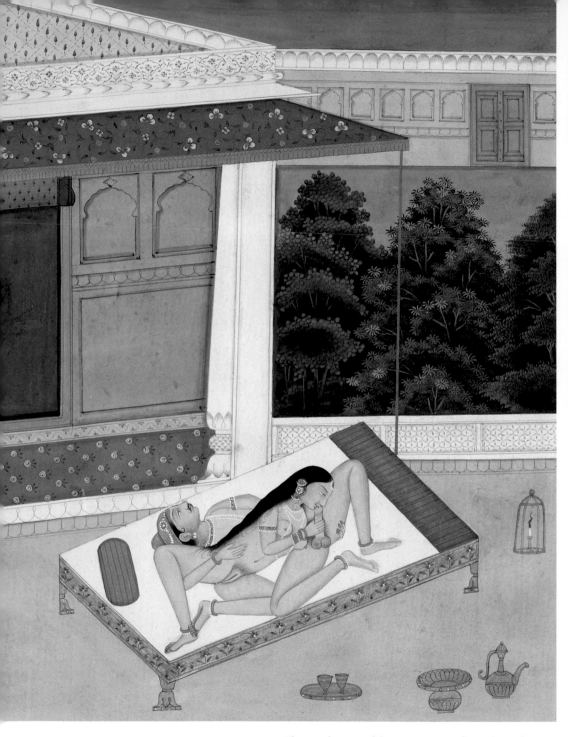

The mouth is one of the main sources of sexual gratification.

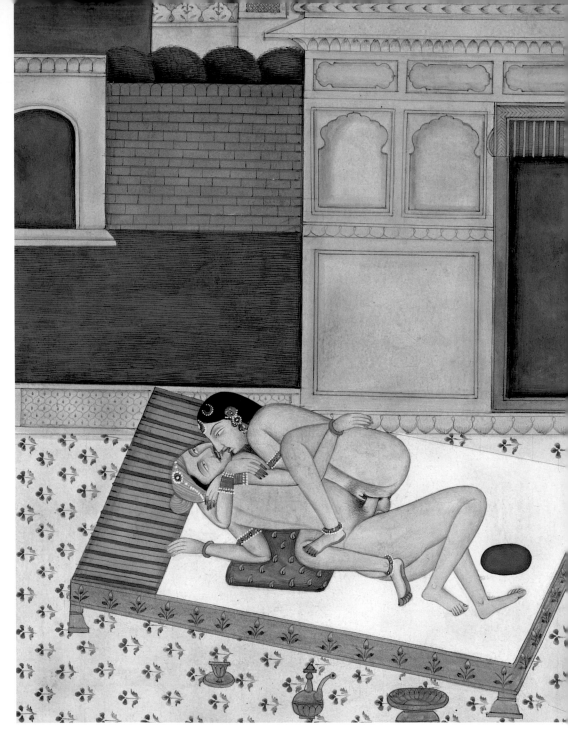

A woman on top reveals her true passion that may otherwise lie hidden.

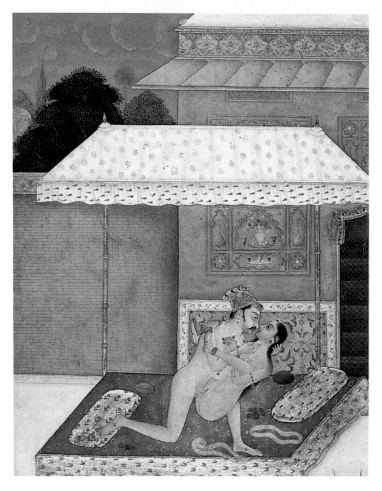

Intimacy begins in the mind, then translates on the physical plain.

Facing page: *A man who wavers for too long even when the woman
is ready, is an incompetent lover.*

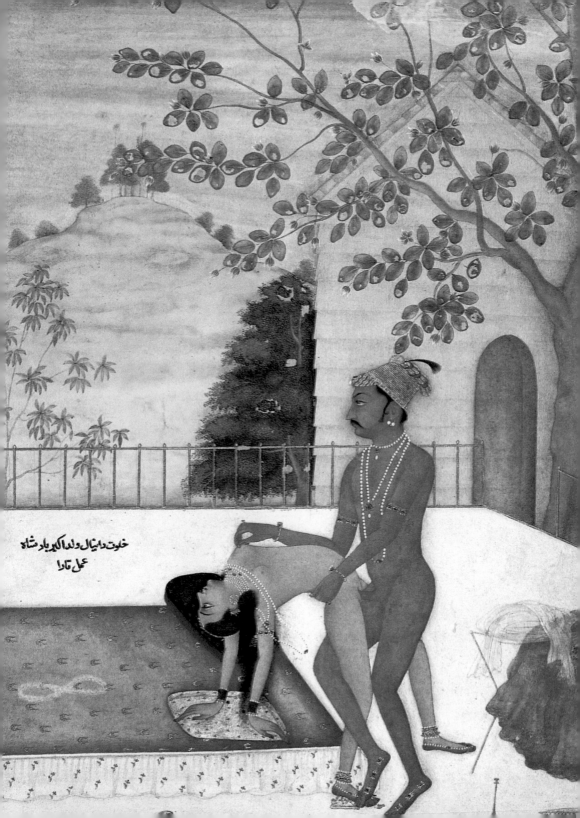

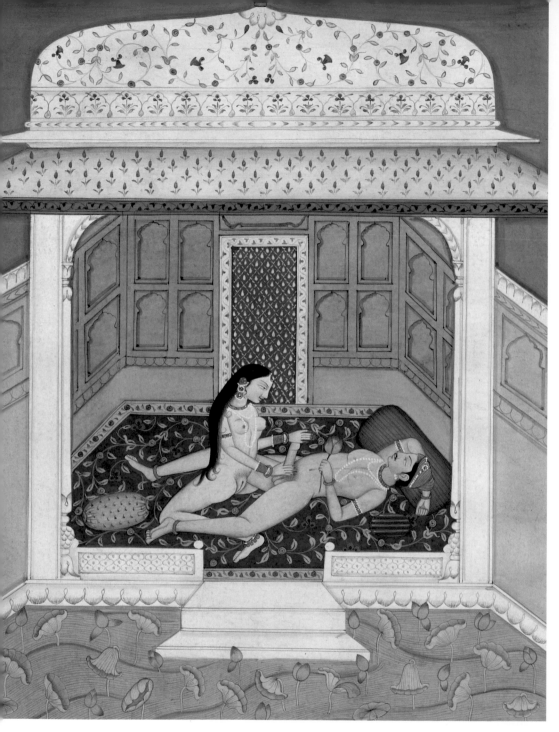

Desire is something to be celebrated, as a path to moksha.

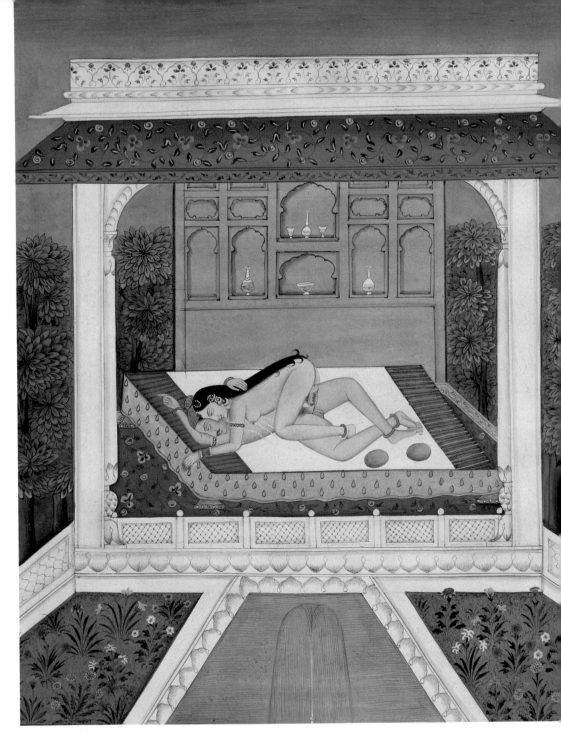

Vatsyayana encourages the reversal of roles in the act of making love.

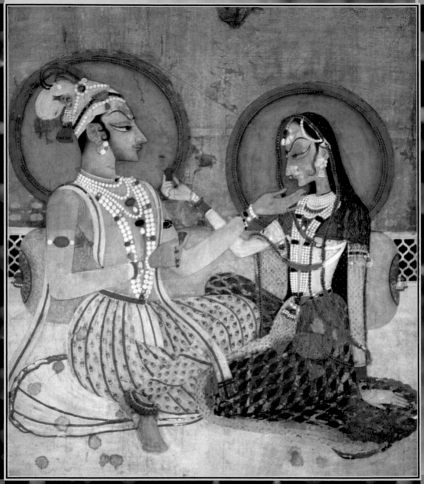

The Need
for Preparation

\mathcal{V}atsyayana's edifice of carnal fulfilment was based on two quite revolutionary supports: one, that men and women are equal participants in the act of making love; and, two, that there are often fundamental differences in their definition of a fulfilling sexual experience. Men are more easily and, alas, much too quickly satisfied. For women, sexual intercourse has to go beyond just a fleeting physical contact. It is not that women have a smaller sexual appetite. Quite amazingly for the male-dominated time he lived in, Vatsyayana had a realistic and accurate appreciation of a woman's libido, which, once aroused, could leave a man limp at the post. The operative phrase here is 'once aroused'. Sitting on the banks of the river Ganga in the holy city of Benares almost two thousand years ago, and basing his inference on works that went back another thousand years, our wise seer concluded that passion in a woman is a spark best ignited when the person, mood, time and ambience are right. Only then does it become a flame

burning fiercely in the intimacy of the space she needs, and is ready to become a conflagration.

A man who wants to be a good lover should, therefore, look upon the actual act of coitus as the sanctum sanctorum of a many-splendoured mansion. The journey has to end at the sanctum, but not before it passes through many wonderfully embellished rooms with their own irresistible distractions. Ideally, then, the sanctum sanctorum must be approached in a sequence that renders the journey as rewarding as the destination. Otherwise, the goddess will never be fully satiated, although if she loves you, she will very likely never let you know.

A good lover is never in a hurry. Rapid sex has its appeal, and sometimes circumstances may allow for very little more. Vatsyayana, while understanding of such compulsions, is essentially the spokesman of the art of making love, an art that allows both partners, and especially women, to experience the ecstasy of union in its plenitude. Where does this artistic process begin? Usually much before any physical contact. A man needs to understand that while he would like to get down to brass tacks immediately, a woman responds best when she is also attracted to the person she is making love to. This is not to say that a woman cannot make satisfying love unless she is in love with a man (or, perhaps this needs to be said). It does mean, however, that a man who only oozes testosterone and nothing else is less likely to arouse a woman, than somebody who is able to make her laugh and give her a sense of worth, and make her believe that her lover has a brain (even if all he can do is visualise her naked).

The *patra*, or person, thus assumes considerable importance. He need not be an Apollo or an Einstein, but it would be useful if he has discipline, imagination, sensitivity, humour, intelligence and gumption. Frankly, this may be asking for too much, but our guru was quite inflexible on the need for a good lover to have some qualities that enable his personality to be revealed beyond the size of his muscles, while allowing – and this is critical – the woman, too, to be discovered for the individual she is. This is unlikely to happen if the very first word a man whispers to a woman is 'sex'.

On the contrary, if sex is indeed what he has in mind, he must have the ability to create a mood whereby the possibility of sex begins to be whispered in a hundred seductive ways, without being mentioned directly. A good lover should, in other words, learn the very important business of dalliance. For this, he must cultivate certain skills, and Vatsyayana lists sixty-four of them.

The list makes for fascinating reading, revealing the cultural distractions of the period in which it was compiled, but retaining – if we go beyond a literal reading – an amazing relevance to the qualities a good lover needs to cultivate even today. Obviously, the sage did not intend aspiring lovers to master each step. Vatsyayana may be accused of being a bit of a perfectionist, but he was not a sadist. The list is indicative, delineating broad areas of endeavour – a remarkably eclectic mix of the weighty and the lighthearted, and the serious and the trivial.

Music is mentioned first. Lovers do not have to be musicians, but if they can sing or play an instrument, or have the capacity to appreciate good music, they can expect to strike the right chord with women, and begin things on a good note. A man who can paint, or draw a fetching sketch of his lady-love, is likely to brush aside her defences. The man who knows how to dance well, is also on a good footing. He may know nothing about the finer nuances of classical music or art, but dexterity on the dance floor can literally sweep a woman off her feet. A lover with a literary flair is the envy of other men. A love poem can release a woman's hormones faster than any potion; the right verse for the right moment can render most women happily tongue-tied. Of course, not all men have it in them to be poets, but acquired skills such as reciting well-known literary passages, telling a story well, or knowledge of prosody and rhetoric, will do quite as well.

The essential idea is that in the initial meeting, a man should be able to display an interest in things other than the bulge of his biceps or the plunge of her cleavage. Such a supreme effort on his part will help create the right setting for the vital process of discovery and dalliance. This, in turn, can bring about a more enjoyable union than his simplistic sense of gratification

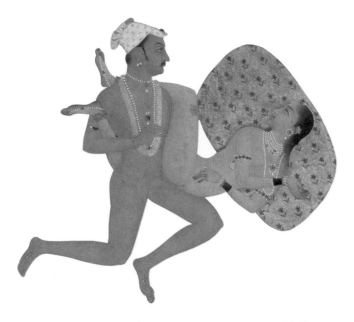

can envision. What are some of the other things he could do? He could, for instance, be good in 'oral puzzles', which in today's times would mean having the gift of the gab and telling a joke well. He could be a good mimic. Making a woman laugh is perhaps the best form of foreplay. He could demonstrate an interest in gardening. A man who, besides looking intently at the woman by his side during a walk in the woods, relates how he planted a certain creeper with his own hands and lovingly nursed it, is likely to have the woman rooting for him. Women have nothing against brawn, but it helps in the first round if they are given the opportunity to find out that there is also a brain lurking somewhere. An area of special interest could indicate this. Vatsyayana mentions architecture, metallurgy, etymology and precious stones, but for the man of today, it could as well be management, philosophy, computers, or anthropology.

Not every quality has to be cerebral. A man who is good with his hands rarely fails with women. Carpentry could be a hobby, and if he were to specially make something for her, he could soon be on the way to more

malleable surfaces. Proficiency in water sports is an asset, probably for the valid reason that so much does go on below the surface. A man who holds a bow and arrow steady, or wields a sword with dexterity, is as good a candidate as one who swings a club to precision on the golf course, or hits an opponent unflinchingly in the boxing ring. Indoor games – for these are, after all, the guru's forte – are not ignored. He mentions proficiency in 'dice games', and this category would include modern counterparts such as chess, bridge and darts.

An accomplished lover should know how to dress 'artfully'. In other words, he should have a sense of style. This does not necessarily mean designer labels; if he cannot afford them, he must know how to 'conceal the defects in the clothes by wearing them ingeniously.' He must know about perfumes and fragrances, too. A man doused in the wrong cologne (or even in the right one) will leave his beloved breathless in more ways than one. Like the feminists of today, our seer was liberated from gender stereotypes: a man skilful in the culinary arts could be guaranteed to start something cooking. The art of making a good drink could impress as well. 'Good' here is defined as resisting the temptation to pour three fingers straight of the most lethal concoction, en route to the bedroom. Fruit drinks and 'spirits of different flavours and colours' are what a good lover should learn about, for these contribute to the general sense of excitement and anticipation, without ending things prematurely. If he knows how to arrange party games, so much the better. Above all, the classy lover should have the right manners. There will be enough time for him to display his masculinity, but in the moment of first contact he should come across as a gentleman, projecting the right grooming and 'knowledge of etiquette'.

Two other areas of expertise are worth mentioning: the ancient art of body massage with rare essential oils, and the knowledge of medicinal herbs and intoxicants with stimulatory qualities. The first can help in arousing a woman; and the second, in keeping a man aroused.

We have now touched upon some of the areas that need to be cultivated by a good lover. The list of sixty-four applies to both sexes. Many of the skills

it mentions can be mastered by men and women, although a few, such as 'colouring teeth, garments, hair, nails, and body' and 'needlework', can perhaps be left to the fairer sex. It must be remembered that the emphasis here is not on the mechanical acquisition of skills, to be flaunted as trophies or cynically used to somehow lure a woman into bed; rather, it is on the making of an intelligent and sensitive lover, who, while not ceasing to be himself, is willing to invest in what could make him more attractive to a woman. He should try and understand what she is interested in, and interpret her desires even if they are unvoiced. He should be able to talk to her on subjects that compel her and be a good listener on matters close to her heart. He should try and avoid the things she dislikes, and attempt to appreciate the things she cherishes. He should make friends with her friends, and, in general, show that he is capable of caring in matters pertaining to the art of making love. Vatsyayana sums it up when he says: 'A man who is accomplished in these arts, speaks well, and knows how to be gallant, will quickly gain the hearts of women.'

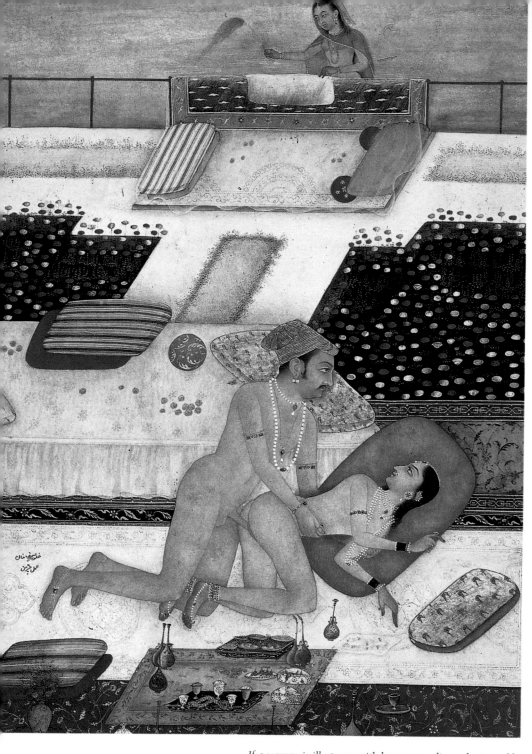

If a woman is ill at ease with her surroundings, she is unable to derive pleasure from the act of making love.

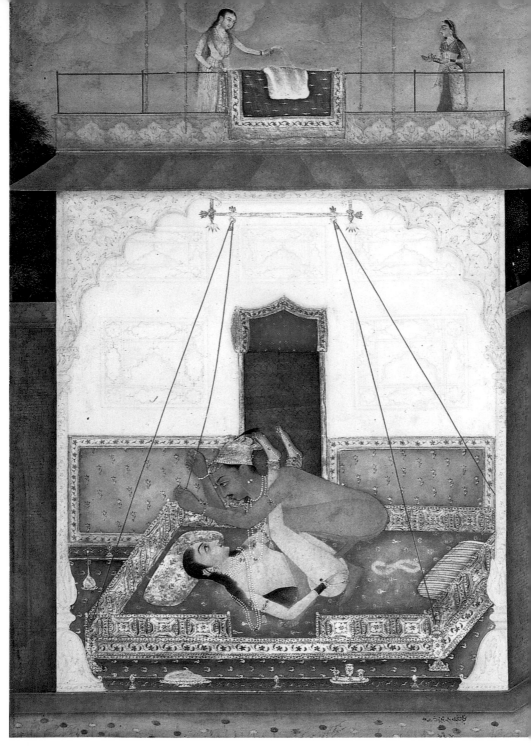

Men and women are summed up in three categories: small, medium and
large. For a fulfilling sexual union, partners must be well-matched physically.

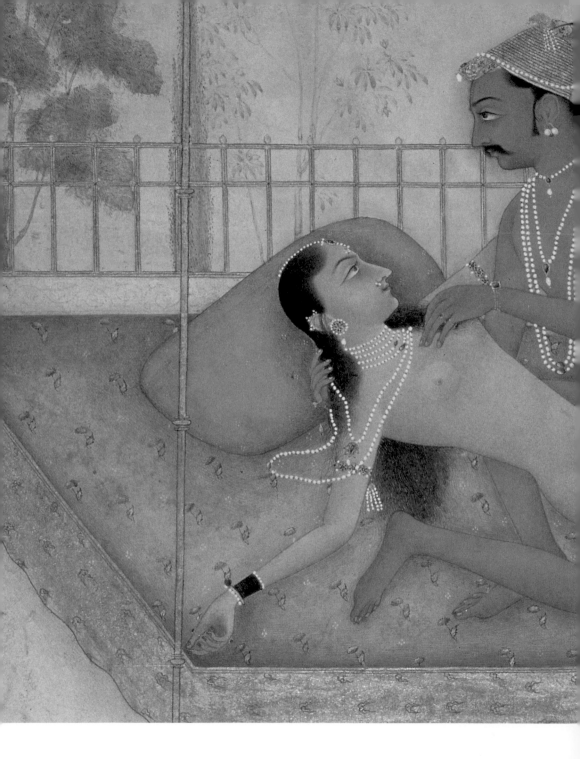

Women took great care to embellish themselves with flowers and jewellery to please their lovers.

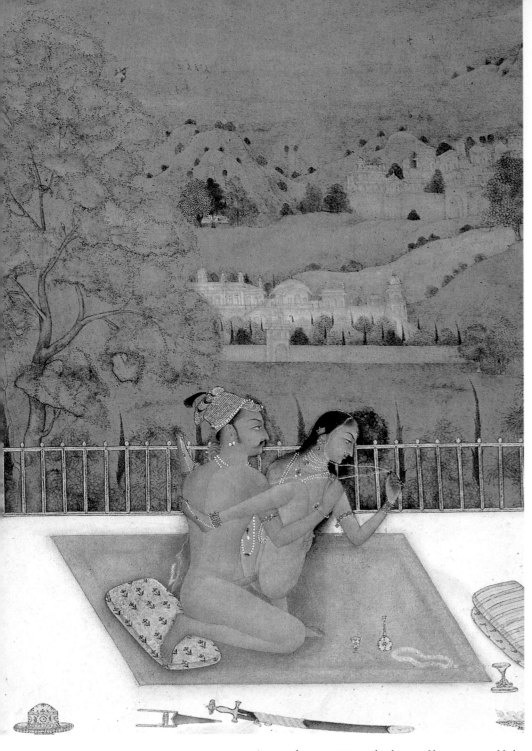

A man who is sensitive to the desires of his woman, is likely to permanently enjoy a passionate relationship.

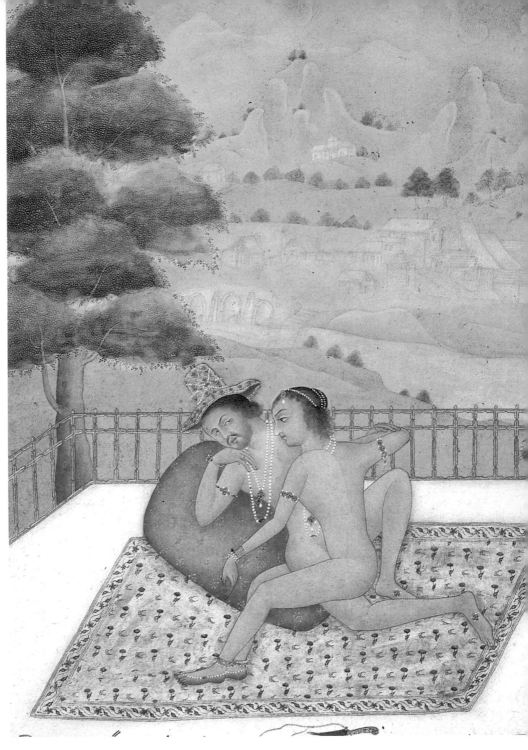

Nothing arouses the man more than when the woman takes control.

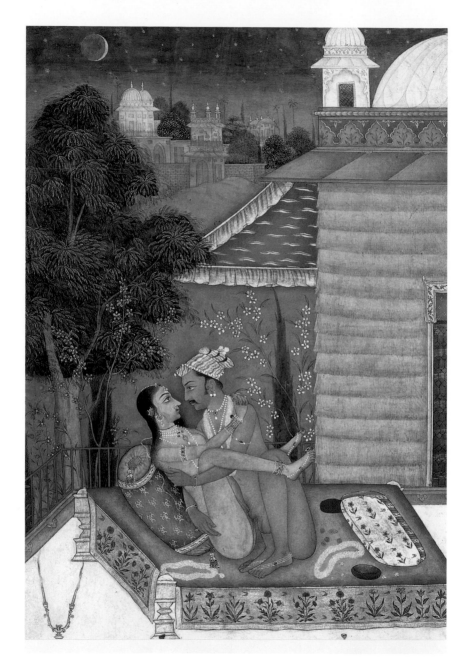

Nail marks are often reminders of old dormant passions.

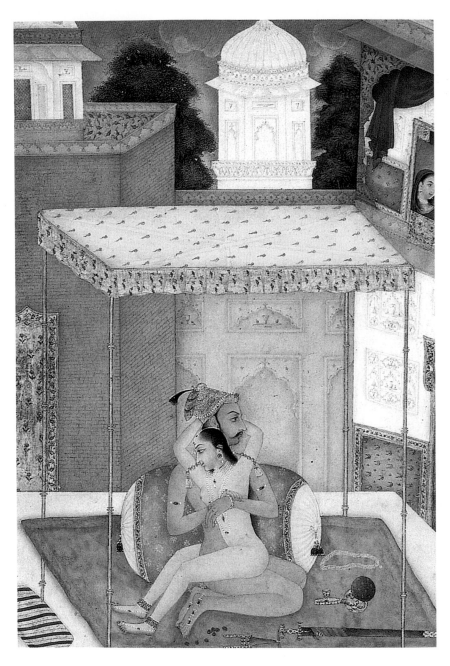

However reticent a woman may be, she is quick to learn the games of love.

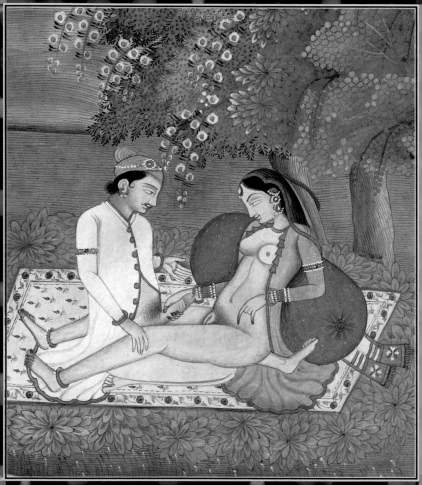

The Right Setting

A man with the right skills and attitude is equipped to be a good lover, but only if he works to ensure that the time and place are right. A man with an erection may be in a hurry, but a woman uncomfortable with the place, or unhappy with the timing, is not going to enjoy the experience to the fullest. A truly satisfying erotic experience is an outcome of the creation of the erotic mood; and the erotic mood has a lot to do with consciously trying to create the right ambience, at the right time.

Vatsyayana has clear advice on both matters. His recommendation is that a man should have two places of residence, one of which should be private. Of course, this is easier said than done. Most men do not have two residences, and certainly very few have a secure hideout that can exclusively be reserved for such pleasures. In fact, in the absence of a suitable pad, morality is for many men simply the lack of place. Yet, however difficult, finding the right place for the amorous tryst is important. The discriminating

woman will hardly be able to relax sufficiently for a languorous climactic experience, if the room in which this is to be enacted is dirty, or lacks privacy. A woman on the edge because the bedsheet is filthy, or disgusted because the place is too seedy, or distracted because someone could walk in at any moment, is not the woman who can participate in Vatsyayana's erotic sequence. Men have to understand that, and do the best possible in the given circumstances.

This being clear, we can now consider the master's description of what constitutes an ideal place. The room where privacy is guaranteed, should be aesthetically decorated and well perfumed. It should have – as one would expect – a bed. The bed should meet certain specifications. A canopy should adorn it, with pillows scattered at the head and the foot. A hard mattress is not acceptable to our fastidious mentor. His preference was for something softer, slightly concave, and covered by a clean, white sheet. Perfumed ointments, flowers and garlands should be kept on a stool near the bed. It also helps if a woman's toiletries, such as a pot of collyrium and a vial of perfume, are within reach. Among alternative sites for congress, a couch and a mattress made of soft grass, with a barrel-shaped cushion for reclining, will serve well. A few books, a lute, a board for playing dice, paper for sketching, and brushes and paints are some other recommended accessories. Outside,

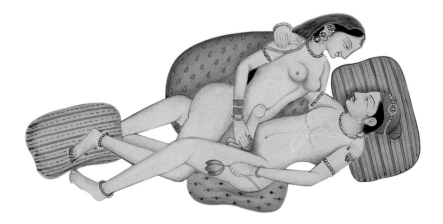

a garden alive to the song of birds – with a swing in the shade of the trees, and a bench in a bower adorned with creepers and flowers – completes the idyllic setting.

The 'delicious postponement of fulfilment,' to quote Freud, is the pulsating motivation in the conjuring of such a setting. A woman invited here is not to be summarily disrobed and pushed to bed, although should this be the wish of both partners, they would do no wrong. The presumption, however, is that she may want (or need) to be appropriately courted before the actual act of intercourse. The tryst, in the privacy of a beautiful locale, is the beginning of a voyage. It could come to a quick end, or it could be delectably strung out. For our guru the latter is an infinitely better option. A man should strive to postpone the obvious by fully exploring the seductions that lead to it, for that may be the best way for the woman to enjoy the experience. All the skills that we have spoken of earlier, must come in handy now. Foreplay does not begin – one can almost hear our *mahamuni* say – when a man begins to pull his pants off. It has already begun when he invites the woman he desires to a place he has tried to make as private and attractive as he can. It has begun to unfold when he tries to make intelligent conversation with her, so that she does not feel like a whore being used for his physical pleasure alone. It is evident when she throws back her head and laughs at something he has said; when he reads to her from a book of his favourite poetry; or when he invites her to settle down comfortably on a couch to play a game of dice or scrabble. It is equally at play when he begins to sketch her portrait (provided, of course, he can draw a straight line), or holds her hand as they sit quietly on the swing.

I can hear some protests that this is becoming all too mushy and sentimental, but I can also hear Vatsyayana's retort that the act of making love does involve sentiments, and women usually enjoy it much more in an environment that respects them as persons. Our wise guide was never one to sacrifice the purely physical pleasures at the altar of extraneous considerations. However, he understood – what many men unfortunately do not – that the purely physical is better facilitated by a 'spiritual' prelude

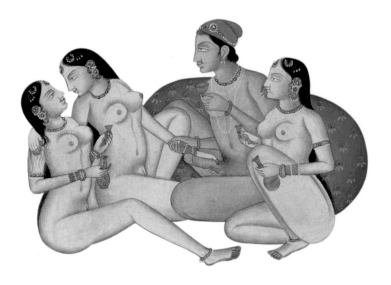

where, apart from the bed, all the other things he mentions a room should have, also play a role. This conviction could not be better endorsed than by the conduct of one of the most lovable and amorous gods in Hinduism – Krishna. The Blue God sported with and made love to the *gopi*s (maids) in Vrindavan. The ancient *Purana*s write that when he played his bewitching flute, the maids, married or otherwise, rushed to him, oblivious to all inhibition or restraint. The texts bring out clearly that Krishna's physical appeal was linked to the right moment and setting, which helped evoke the erotic mood. The flute rang out most clear and compellingly with the onset of autumn, when the monsoon had spent itself, the landscape was lush and green, jasmine and coral flowers and water lilies were in bloom, and the nights were clear and full of stars. His love-play was, thus, one in which the physical was interwoven with melody, grace, a sense of the moment, and the resplendence of nature. *Sringara rasa*, the elusive but intoxicating erotic mood, was the outcome of this heady mix.

Mortals, alas, cannot become gods. What Krishna could do, and get away with, ordinary men cannot. But even with our limitations, we have no

right to treat sensual matters shabbily. This was Vatsyayana's basic point. He continuously exhorts and instructs a man to adequately prepare for the celebration of love. There is no detail too small in this glorious endeavour. A man should not only clean his teeth and apply perfumes to his body, but also eat betel leaves or other things that freshen the mouth. He should bathe and shave daily, anoint his body with oil every other day, use herbal soap powders to keep himself clean, and ensure that there is not the slightest smell of sweat in his armpits. He should have a midday siesta so that he is fresh for the pleasures to follow. When he finally meets her in the evening he should welcome her with refinement, and converse about things that make her feel at ease.

If the preparation and ambience are right, when and how should he take things to the next stage? Our canny teacher is categorical: test the waters, watch her reactions, and judge when she is ready. A physical advance made before its time is disastrous. It should be avoided at all costs. Never assume that a woman is available. A man who proceeds under such an assumption debases the sanctity of the act of making love and demeans the woman. Give her more time if she is not willing to say yes. Try and win her over gradually if she is diffident. If the first meeting does not work, arrange another one. Sometimes a friend, known to both, can be of help in overcoming doubt or inhibition. Take his or her help. Make exploratory moves. The guru gives an interesting example. If she is pretending to be asleep, rest a hand gingerly across her; if she allows it to lie, and removes it only on 'awakening', interpret this as an invitation to do more. The important thing is to assess her reaction to the first attempt at physical contact. If she repulses his embrace but meets him happily in exactly the same circumstances the next day, her opposition can be considered more simulated than real. On occasion she can take the initiative, and that is, of course, ideal because a man cannot be trusted to use his brains beyond a time. For instance, if without being approached she invites him to a 'lonely spot', he has reason to celebrate. But even here the guru stresses the need to observe. If she trembles, her hands and face perspire, and her voice falters or quivers, things would appear to be

going in the right direction. If, pretending to be tired, she leans against him, and there is the unmistakable pressure of an embrace, or when embraced by the man, she extricates herself only after a delay, that too is a good sign.

Once convinced of her willingness to proceed further, all hesitation and fear should be jettisoned. He who hesitates for too long even when the woman is ready, is an incompetent lover. However, in the beginning the touch should always be gentle, unless the woman wants otherwise. In this respect Vatsyayana could be extreme. A bridegroom, he says, should commence his amorous advances 'in a delicate manner' after a period of four days of celibacy following marriage, during which he should try to know his newly wedded wife; for a husband and wife rarely knew each other before marriage in his days, and the situation has not changed dramatically even today. Initially, he should embrace only her upper body. He should kiss her gently, without a sound. At first his hands should only brush past her nipples. Only on the second and third nights, when he has gained her confidence a little more, should he caress her thighs; and only if she does not object, should he move his hand upwards in stages to the point where her thighs meet. His approach should never be rash. He should always be gentle and considerate, for women are like flowers, says our guru. They like the delicate touch.

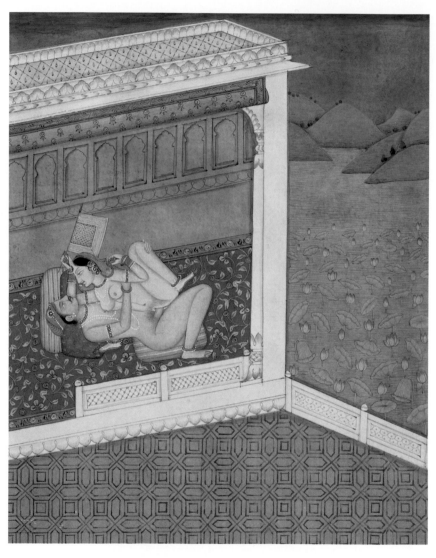

After the passion is spent, Vatsyayana suggests that the man be attentive to his beloved by engaging her in conversation under the moonlit sky.

Facing page: Long, flowing hair is considered an ornament, enhancing the beauty of a woman.

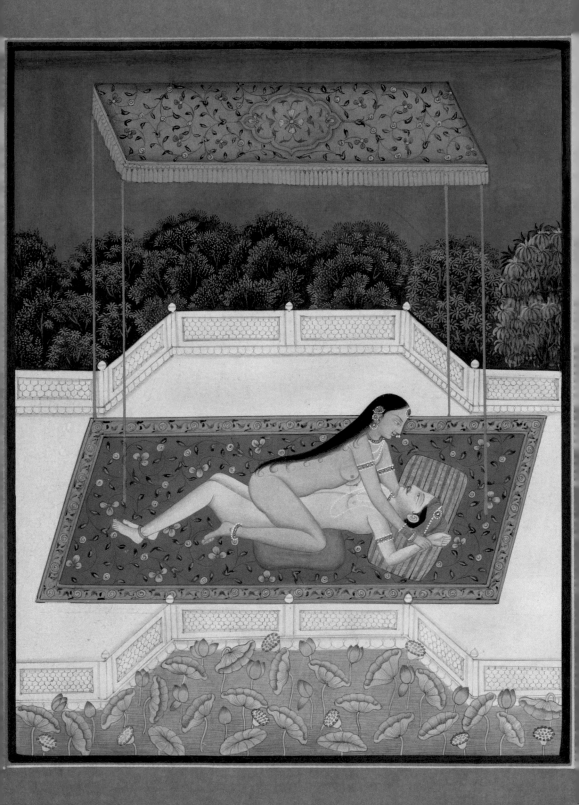

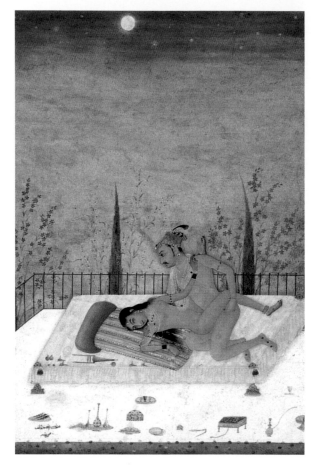

*A woman in love gives herself to her amour
without reservations.*

*Facing page: Embracing while listening to the sounds
of nature can be a sexual stimulant.*

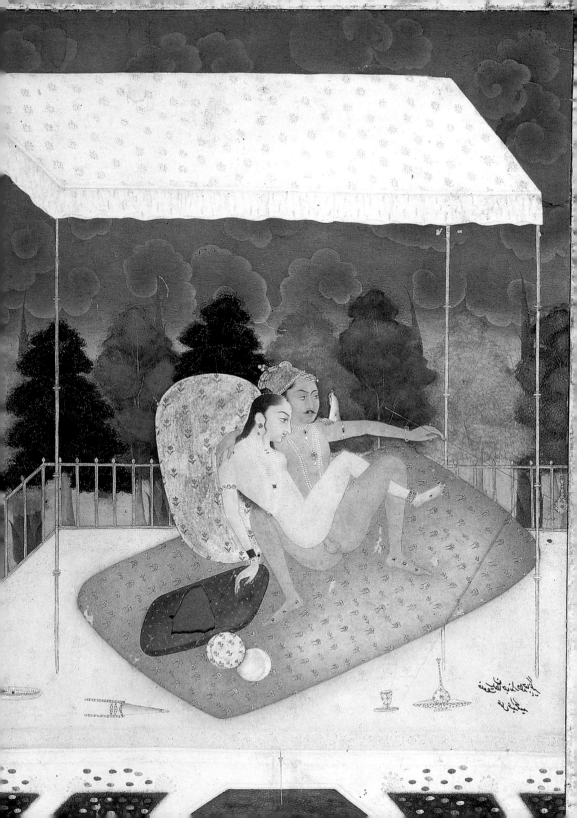

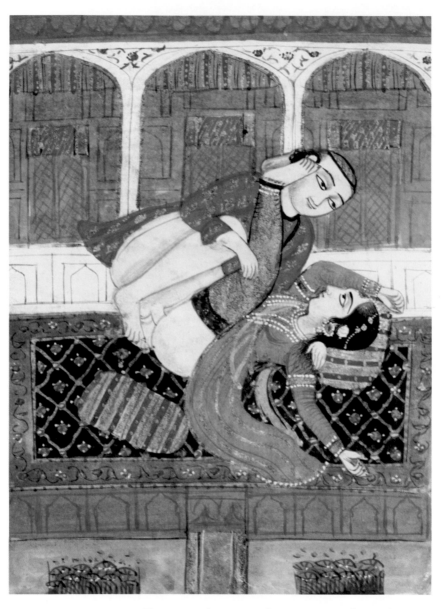

Vatsyayana advises men to learn to interpret the sounds women make during the act of making love.

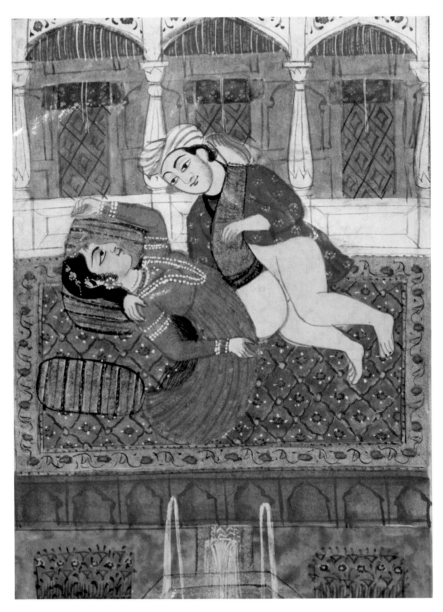

Love is not bound by a specific time or place.

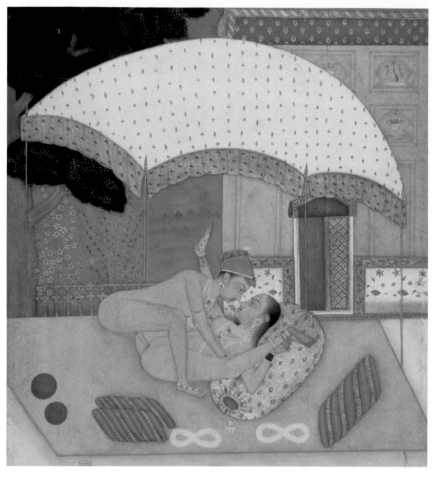

At the height of passion, lovers may lose sense of all propriety.

Facing page: *Couples are encouraged to try different postures in order to avoid monotony.*

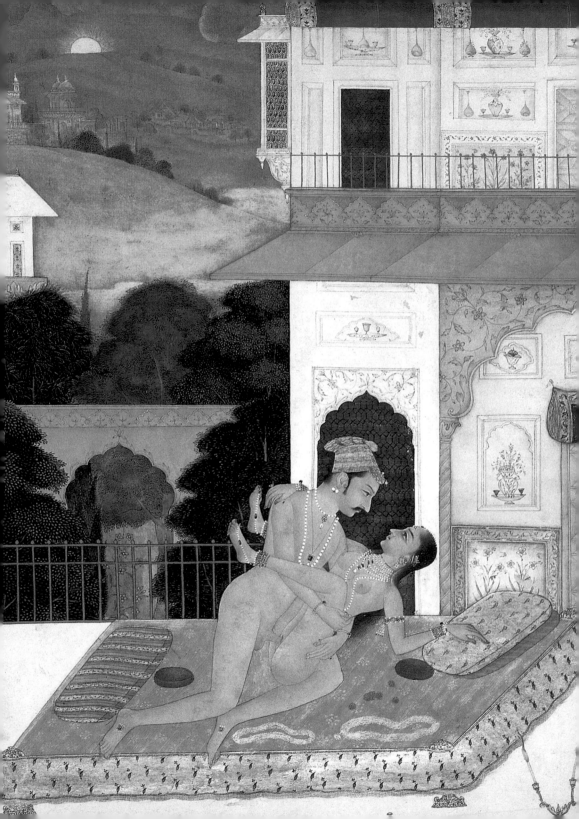

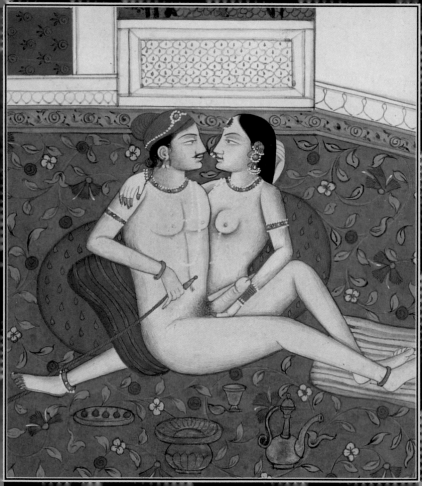

The Needs
of a Woman

*I*t was perhaps Vatsyayana's consistent preoccupation with the needs of a woman, that made him consider the types of union depending on the size of a man's penis and the depth of a woman's vagina. Most people would consider such study to be a measure of an unnecessary form of probing. They would not be entirely wrong in feeling that our revered guru went too far, and perhaps much too deep. Even if he knew his subject in great depth, was there a need to go to such lengths?

According to Vatsyayana, men and women were biologically in one of three categories: big, medium and small. For purposes of clarity, and to avoid any possibility of misinterpretation, he gave a label to each. A man with a big penis was in the 'horse' category; one who could reach a little less far was a 'bull'; the bearer of the small-is-beautiful variety was a 'hare'. Women were similarly categorised. Those who ran the most deep were 'elephants'; those less accommodating were 'mares'; and those closest to the surface were like 'deers'.

We are within our rights to wonder how our celibate master collected his data. What kind of fieldwork this must have entailed? How would he have so precisely observed the 'elephant', 'mare' and 'deer' women? Did he sally forth with a scale in his hands? Was he right to elaborate, like some scientist in a laboratory, on the physical and behavioural traits of those so classified? We can only speculate on the answers, and envy or pity his methodology. Characteristically, the man himself is quite unfazed in coming to the conclusion that 'equal unions' are the best. In other words, a 'horse' man would perform best with an 'elephant' woman; a 'bull' would be ideal for a 'mare'; and a 'hare' would best fit a 'deer'.

Undoubtedly, Vatsyayana was sometimes too taken up by measurements and categories. Even so, it would appear that his overall concern was less with centimetres and more with sentiments. All women are not alike in every respect, was the essential message he wanted to convey to men. Some men and women are better matched physically. Other permutations and combinations are equally valid, but men must be sensitive enough to treat each woman as unique, with her own 'specifications' that need to be taken into account, without hindering the spontaneity of lovemaking.

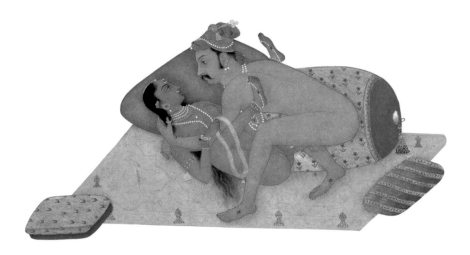

Indeed, the guru's subsequent observations, immediately after he mentions the different categories of men and women, make it abundantly clear that he considered women far more versatile than the depths of their vaginas. Men and women could be of small, middling, or great passion, he says, but whereas men 'when engaged in coition, cease of themselves after emission, and are satisfied,' it is not so with females. The full import of this observation should make us draw our breath in sharply. We need to recall once again that Vatsyayana was writing the *Kama Sutra* close to two thousand years ago. That was a time when, in most parts of the world, women were seen primarily as procreation machines for the exclusive pleasure of men. Their needs, their manner of reacting to the physical experience, their notions of sensual pleasure, and the secrets of their bodies were as unknown as, say, the fact that the earth is round. It was a male-dominated society; men desired women, and women were available for their pleasure; and any other notion of reciprocity was both irrelevant and undesirable. And here we have our sage making it crystal-clear that the parameters of a woman's physical fulfilment are different from that of a man's.

Vatsyayana goes on to explicitly state that a woman loves a man all the more if he is 'long-timed', and is dissatisfied with he who is 'short-timed'. Of course, this is a (not so popular) truth known to most men, but it must have required courage to confront them with it in an age when many of them genuinely believed that their own climax was the legitimate finale for women, too. Vatsyayana was, thus, far ahead of his times in urging men to develop the requisite staying power, not as some transcendental goal, but because this would enhance the pleasure of women, and hence increase their own desirability.

There is nothing wrong, our guru continues, in women expecting men to be able to perform to their expectations. If a woman takes longer to reach sexual fulfilment, and if she is seen to be enjoying the process, then 'it is quite natural that she should wish for its continuation.' A woman's passion needs to be studied, argues Vatsyayana. His view is that a woman's arousal is like an arc: middling to begin with, but increasing by degrees and reaching

a point where, in the intensity of the experience, she ceases to be aware even of her body, until, finally, she wishes to stop all further coition. Men of all kinds – 'horses', 'bulls' and 'hares' – need to take this into account, for if they get into the act of penetration straightaway, their vigorous thrusts may be – at least for the woman – a lot of heaving simply ceasing much too quickly. To bolster his argument, Vatsyayana cites the potter's wheel or a spinning top. Both can revolve very fast, but to begin with their motion is slow, and they spin rapidly only by degrees. Likewise, a woman's passion only gradually picks up tempo. Vatsyayana quotes a sloka to stress his point:

> *The emission of semen gives the man the long-sought-out pleasure; a woman, however, enjoys the union throughout.*

Thus, men and women are consumed in a similar manner by the pleasurable flame of desire, but for the fire to burn most brightly, men must understand that women can, in some respects, be different in how they experience

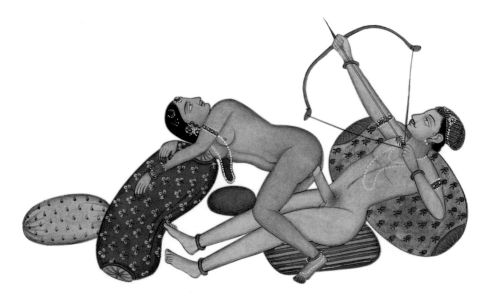

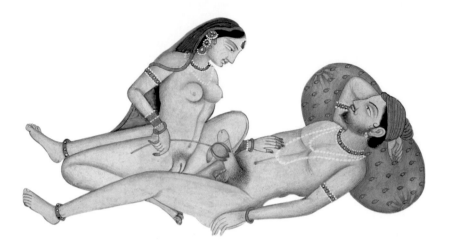

pleasure. By way of illustrating this difference at the psychological level, Vatsyayana observes that in the act of making love, a man thinks, 'this woman is united with me,' while a woman thinks, 'I am united with this man.' Many women will condemn such an assertion as sexist, but I believe many others will agree that the percipient seer has put his finger right on the spot. In any case, this ideological debate need not distract us. Vatsyayana's principal point is that women experience sexual pleasure in as intense a way as men. Men should know this; and they should also try and ensure that this pleasure is not denied. Another sloka quoted by Vatsyayana sums it up well:

> *Men and women, being alike, feel pleasure in the same way; a man must, therefore, first arouse the woman by fervent love play, and then make love vigorously so that she reaches the climax earlier or at the same time as him.*

There are other examples of accurate observation. On the first occasion, Vatsyayana says, the male is likely to climax very quickly. His performance

can be expected to improve in subsequent unions on the same night. In the case of the female, the reverse is true. In the first instance, her time may be 'long', but on 'subsequent occasions on the same night, her passion is intense and her time short, until her passion is satisfied.'

Our *mahamuni* is without doubt the unrepentant spokesman of the validity, desirability and possibility of a woman's orgasm. Of course, women do not need a spokesperson for something that can come so naturally to them. Indeed, it is men who need to be reminded of what they must know and learn to do. The advice on the three basic kinds of women is part of such an approach. It does not require men to go to a lovers' tryst with a measuring tape; it only requires them to understand that each woman is a microcosm unto herself, with her own specific code for physical fulfilment. Once this understanding dawns, men become better 'horses', 'bulls', or 'hares' in responding to the needs of women, be they 'elephants', 'mares', or 'deers'.

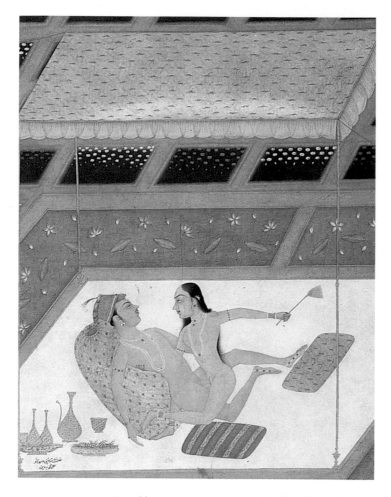

A good lover is sensitive to every detail. He keeps food and drink near at hand for his beloved.

Facing page: *Partners should match physically as well as emotionally for a perfect sexual union.*

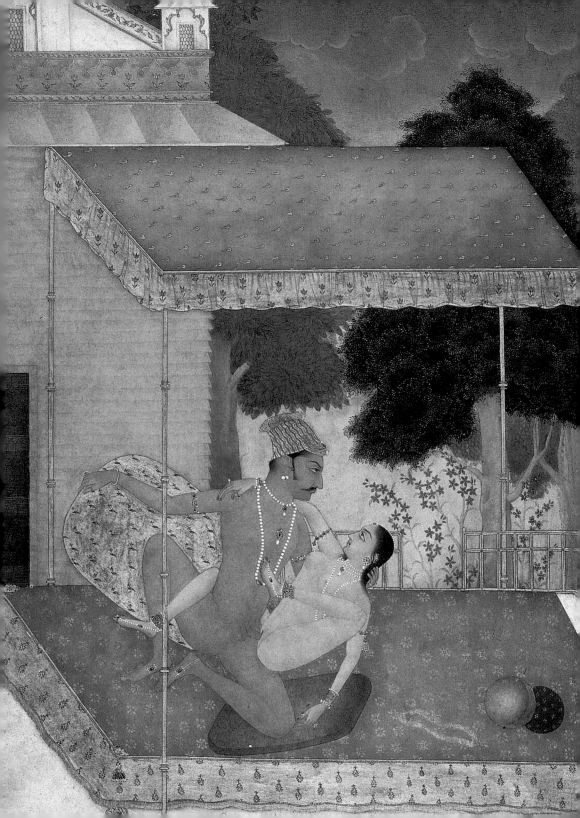

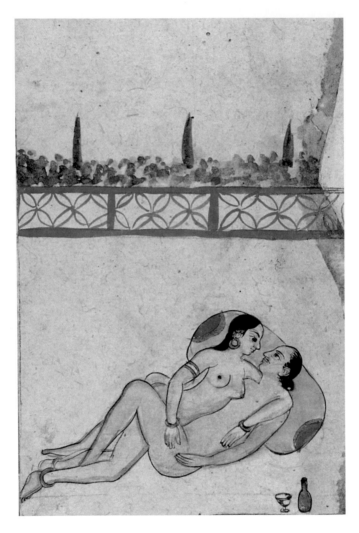

Touch, sight, smell and sound are all important components
in the act of making love.

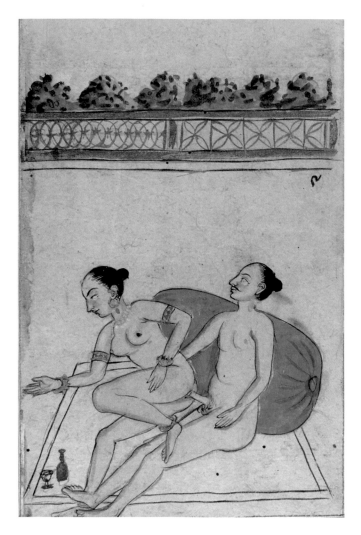

When passion is spent, Vatsyayana suggests that lovers lather sandalwood paste over each other.

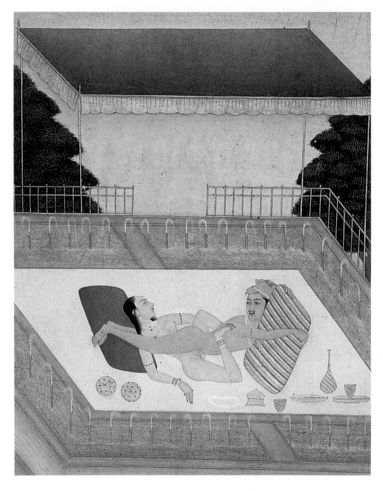

Vatsyayana advocates the practice of all the sixty-four postures in the Kama Sutra.

Facing page: *In the heat of passion nothing seems in excess, as lovers give themselves entirely to one another.*

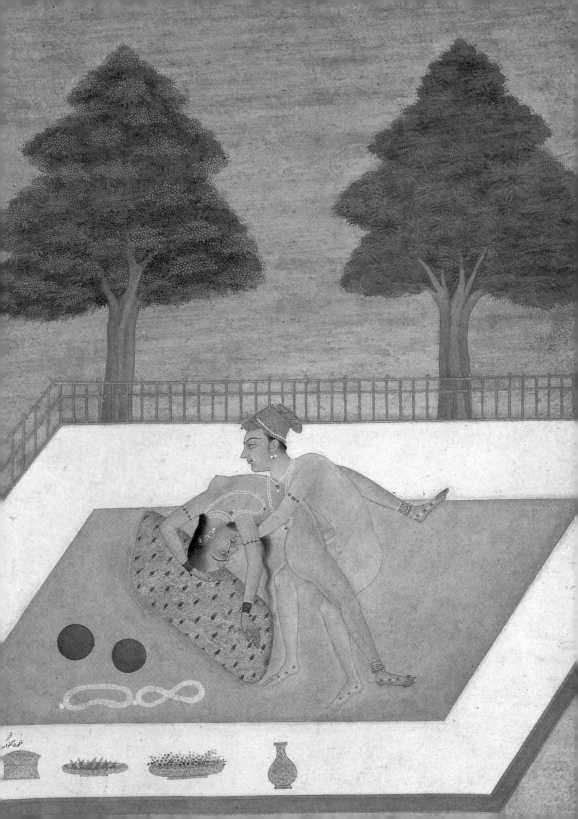

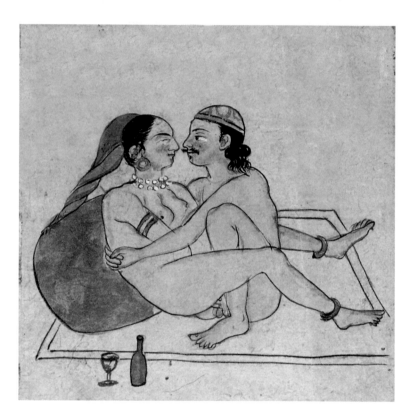

*A good lover is never in a hurry. He knows that the time leading
up to the act is of utmost importance.*

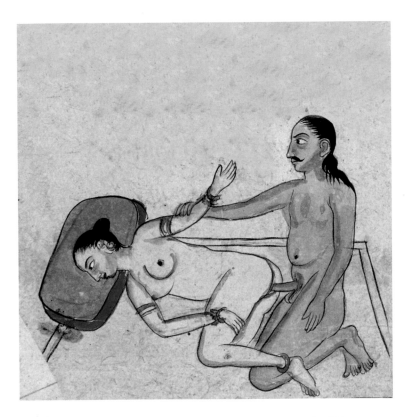

Vatsyayana laid down the liberating precept that the act of love should be free of guilt and any notion of sin.

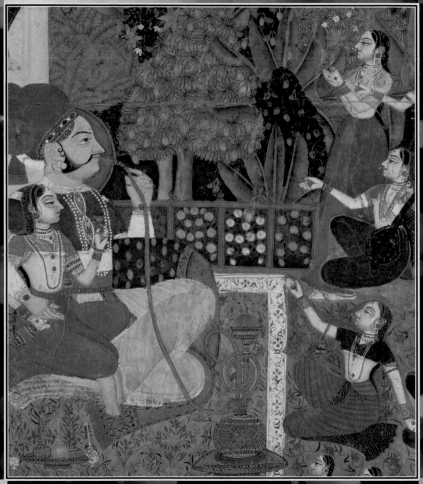

The Embrace

*E*nough of theory, I can hear my more impatient readers say. What about getting down to actual practice? The truth – as must surely have become evident even to the most obtuse reader – is that for Vatsyayana there is no difference between the two. Practice, without the knowledge of the right approach and attitude, is a soulless exercise in mechanical friction. And theory, without the opportunity of practice, is a waste of time.

The two must go together, but sometimes the great mentor could test our patience. Just as he is about to describe the first step of actual carnal contact – the embrace – he cannot resist going over the seven stages of passion for lovers. First, they will feel sheer exaltation, both physical and mental – *rasa* and *rati*. Second, they will experience the consciousness of pleasure, generated by a meeting of minds and the anticipation of physical contact – *priti* and *bhava*. Third, during the course of physical union, they will feel the emotion of love coursing in their veins and filling their entire

soul, as it were – *raga* and *vega*. Fourth, in the combination of love and sexual pleasure, they will lose their sense of duality and all sense of inhibition, allowing their two hearts to beat as one – *sampati*. Fifth, they will reach a stage of ecstasy, when the body and the spirit 'conjoin' – *samprayoga* and *rata*. Sixth, they will seek the bliss of post-coital rest, peace and quietude – *raha* and *shayana*. And lastly, they will savour a sense of transcendence, where the mind is literally lifted above the mundane – *mohana*.

The description of this joyful linear path is undoubtedly meant to nudge lovers – and especially the man – to go the whole course. But let us start at the beginning, with the *alingam*, or the 'embrace'. A man and a woman who have not met before, but are attracted to each other, can display their intentions through four variations of the embrace. In the first, a man must find a pretext to pass close to the woman he desires. In doing so, if he can make his body touch hers, it is called *sprishtaka*, or the 'touching embrace'. When a woman, taking the initiative, bends as if to pick up something when alone with a man, and presses her breasts against him, and the man, not letting the opportunity pass, holds her breasts and pulls her in a tight embrace, it is called *viddhaka*, or the 'piercing embrace.' Vatsyayana clarifies that these two embraces take place between those who have not yet spoken of their attraction to each other. When lovers know of each other's

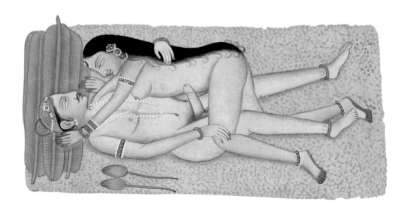

intentions, they can dispense with pretext. If they allow their bodies to deliberately rub against each other when walking together in the dark or at a lonely place, or even in a crowd, it is called *udgrishtakam*, or the 'rubbing embrace.' If the man takes matters further, by pressing the woman hard against a wall or a pillar, he is practising *piditikam*, or the 'pressing embrace.'

The Sanskrit labels indicate the precise terminologies in the ancient texts. However, we propose to largely dispense with such tongue-twisters from now on. The important thing is to try and understand the substance of the guru's instructions. Quite clearly, he has no time for the hesitant man who will not act even when the moment is at hand. A good lover knows of the spiritual poetry of love; he must also know how to make the right physical beginning. There is no point in his colliding with the woman he desires in a way that leads her to think he has only tripped over something. A signal, weakly or ineptly conveyed, or a gambit excessively ambiguous, is a waste of time. And so, a man must respond promptly when a woman makes the advance. A woman would definitely give a thumbs-down to a man who, on seeing her bend revealingly before him, yawns; or who, when she finds a way to 'inadvertently' rub her breasts against him, asks her what time it is.

The first step towards physical contact is usually the most difficult. Mutual consent, of course, remains the constant and absolute imperative. In order to judge the situation correctly, Vatsyayana suggests the stratagem of the unintended embrace. If the woman conveys disinterest, the man should walk carefully when she is around, and instead of attempting to touch her, plan a complete detour. However, when consent has been conveyed, physical contact helps to reinforce it. A walk in the dark or at a lonely place provides an ideal setting to make a beginning. If the barriers of physical inhibition appear to have been overcome, and there is a wall or a pillar conveniently at hand, a man can do no better than to guide the lady to that strategic support and attempt the 'pressing' embrace.

When lovers meet to make love, the embrace is the most spontaneous form of first expression. In fact, it is so spontaneous that men and women

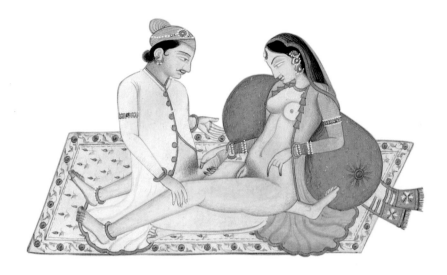

often see it as an undifferentiated act. Vatsyayana urges them to try and be more discriminating. A brilliant diamond may dazzle effortlessly, but appreciation of its worth will multiply manifold if we have the patience and the good taste to examine it a little more closely, and run our hands slowly over the carefully crafted cuts that have gone into its making. A man should try and notice the myriad ways in which a woman can embrace him. In doing so, he will not only enhance his own pleasure a hundred times, but also educate himself to respond to her in a hundred pleasurable ways. Our guide describes but a few of these infinite variations, and the mind bows in amazement at the sheer range of his repertoire.

A woman could cling to a man like a creeper twines around a tree, pull his face down for a kiss, suddenly pause, make a moaning sound or let out a soft shriek, embrace him passionately again, and then, supporting herself against his body, just continue to gaze at his face, almost in disbelief. Or, she could put one of her feet on his, press against his thighs, and with one hand on his back, use the other to pull his shoulder down, as though she is trying to climb up his body to reach his lips, moaning and panting all the while.

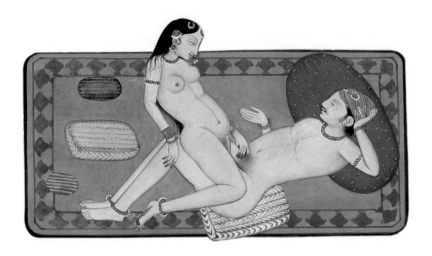

A satisfying sexual experience is the guarantor of the next one: every detail, each nuance, every surge of the flame of passion is important, and must be cherished not only to enhance the pleasure of that moment, but also for the faculty of recall that it inspires. Very often, the mere memory of how it unfolded is enough to reignite passion. A man must be alive to this fact and take in the full flavour of the experience. Naturally, he must also respond in a manner fulfilling to the woman. At some point – if the woman has not already moved in that direction – he must make the transition from the vertical to the horizontal. Timing can be flexible, but it is not unimportant. When a woman has been aroused enough to embrace him as if she were a vine clinging to a tree, or if she is pressing against his thighs while trying to reach his lips, it would not be unintelligent to guide her quickly to the horizontal position (although, as we shall see later, there are rather difficult 'standing' postures too).

In bed, a man must return pressure for pressure, embrace for embrace. If lying on his side, he must encircle the woman with his arms and thighs so tightly that it makes them both as indistinguishable as 'the mixture of sesame seed and rice'. In another variation, he may, while the woman is on his lap, or facing him, or lying next to him in bed, embrace her with so much

force – oblivious to any notion of physical pain or hurt – that she feels he is entering her. This embrace, where the lovers almost merge with each other, has been described as 'the mixture of milk and water.'

There are other variations as well. One is the embrace of the thighs. Here one lover takes the other's thigh or thighs between the legs and presses it with force. When a man mounts a woman and presses down on her middle, as though he is making love to her, while kissing or scratching or biting her, and she, covering him up with her dishevelled hair, seeks to lift up her thigh inviting him to enter, then it is the 'embrace of the middle parts.' A man could also place his own breast between a woman's nipples and proceed to squeeze them. This would be the 'embrace of the breasts.' If, while holding a woman close to him, a man kisses her mouth or forehead or eyes, and she does likewise, it is called the 'embrace of the forehead.'

The descriptions cited by Vatsyayana are meant to be illustrative. They cannot be exhaustive, because human ingenuity in such matters is infinite. Their purpose is to alert the intelligent lover to the many variations possible, not to artificially constrict him to only these. Even a clinical massage can, depending on the intent of the masseur, become a kind of embrace, although our guru is inclined to exclude it since its 'purpose' and 'character' is different.

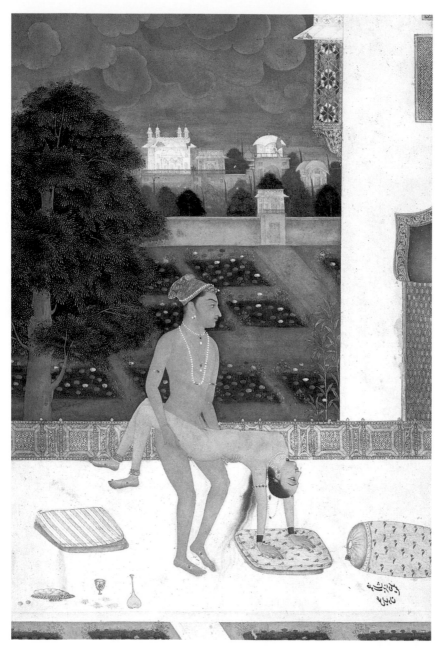

The 'congress of spontaneous love' occurs between people who are
attached to each other and are free to act as they wish.

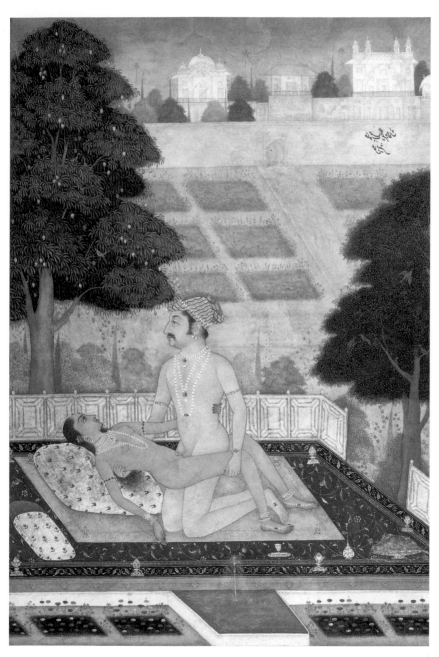

A beautiful, well-decorated setting is the perfect backdrop for lovemaking.

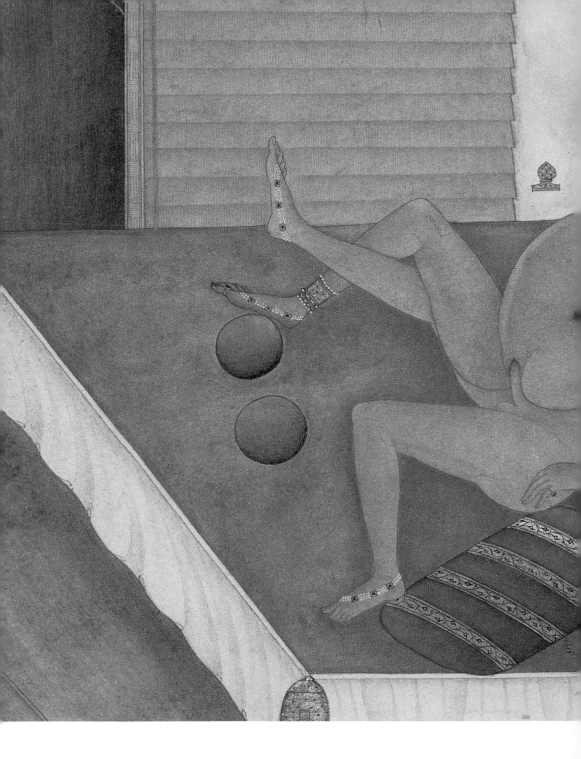

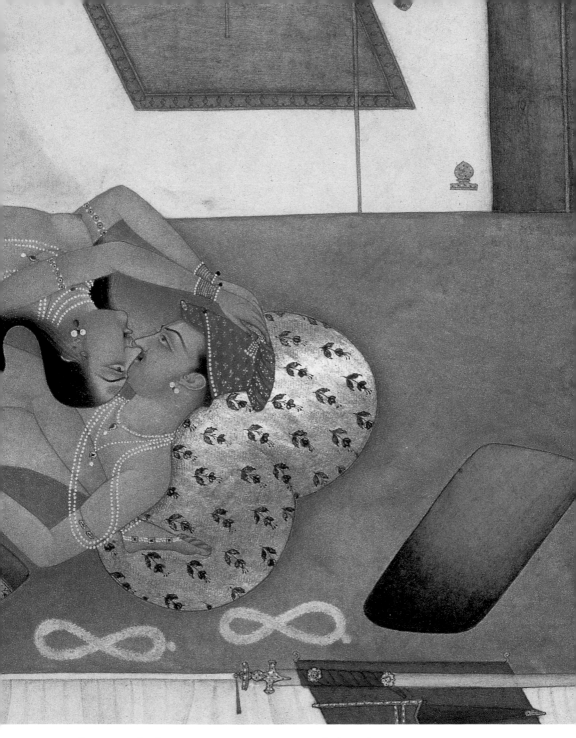

The woman who shows dexterity in love is the source of infinite pleasure.

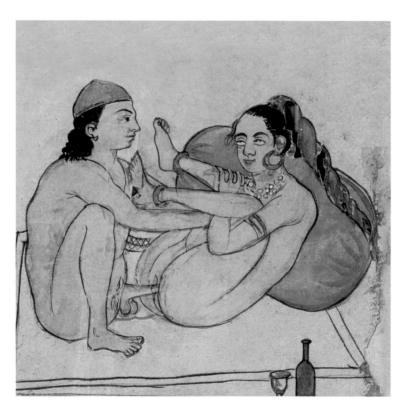

With practice, one can master the different postures of the Kama Sutra.

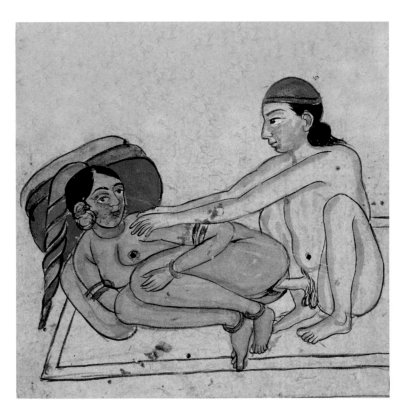

A man must bathe with scented soap, apply special oils, and freshen his mouth with betel leaves, in preparation for his nocturnal encounter.

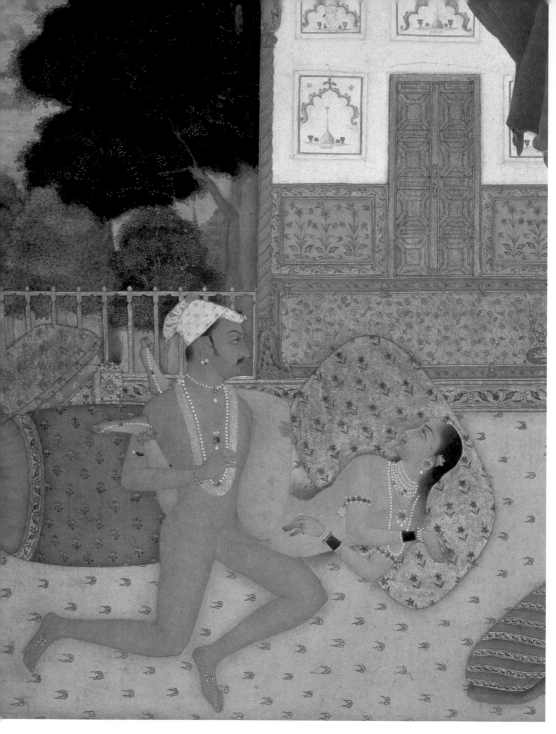

A woman instinctively knows what is expected of her in the act of love.

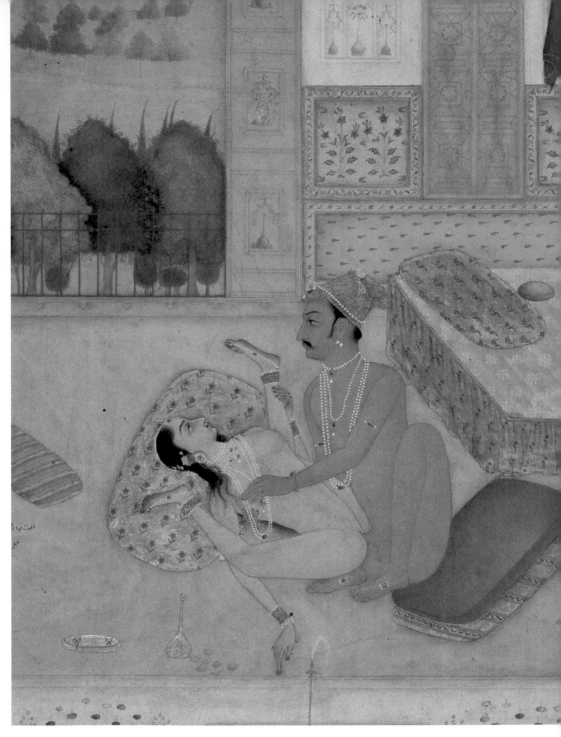

A woman's arousal is like an arc, says Vatsyayana – middling to begin with, then rising to such a limit that she ceases to be aware of her own body.

99

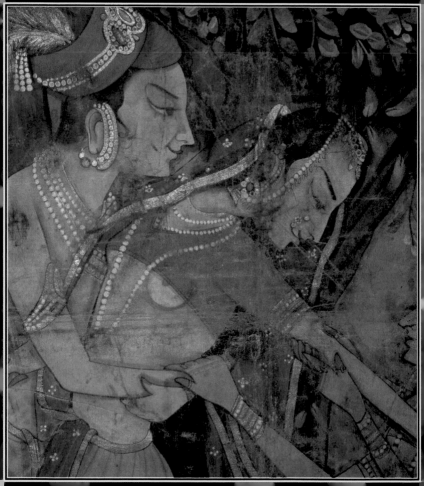

The Kiss

*T*hose daunted by the many instructions thus far should take heart. Our guru would not like to be seen as a tyrant stomping around a bedroom with a stick in hand, to hit lovers if they do not perform in accordance to his rules. He makes clear with all the emphasis at his command that the *Kama Sutra* is in the nature of a guide. Its instructions should not be seen as etched in stone. They are to be followed in spirit, not to the letter. When the wheel of passion begins to roll, there is no manual and no fixed order. An embrace can be preceded by a kiss, and a kiss by an embrace. The ways of passion are unpredictable; that is precisely why sex can be such a perpetual source of delight. Yet, even in this wonderfully unstructured tumult, one thing remains consistent: a man must be sensitive to the needs of a woman, and give her the scope to fully express her physicality.

A kiss is not merely the meeting of lips. It is a complex form of communication, involving many other parts of the body in a great many

variations, each enjoyable in its own distinctive way. A man should, therefore, seek to retain the simplicity and intensity of the act of kissing, while being aware of the erotic complexity of its practice.

Vatsyayana clearly identifies the proper places for kissing: the hair, the forehead, the eyes, the cheeks, the lips, the inside of the mouth, the throat and the breasts. He is a little less enthusiastic about the practice in a certain region of the country where men also kiss the area where the thighs join. His reservations do not stem from any considerations of morality. As always, it would appear he has the reaction of the woman in mind. Such deeply intrusive kissing below the waist may be a case of 'too much, too early'. The entire body is waiting to be joyously discovered. If a woman is willing to forget the linear progression and wants to get straight to the thighs, a man must, of course, rise to the occasion. But if she wishes to move slowly, confining herself to areas where she is more comfortable to begin with, he should respect that hesitation. In any case, there is no reason for him to feel deprived. A woman who has allowed him to kiss her on the eyes and lips and breasts, has already become the source of the most divine pleasure. He should have the refinement to savour this divine offering fully, and not rush into deeper waters before she is willing to swim along.

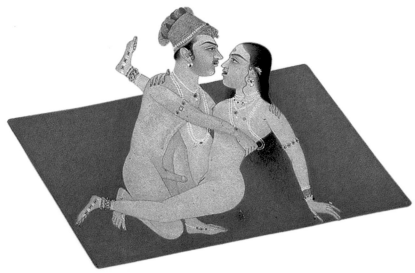

Similar considerations prompt the guru to suggest that when lovers meet for the first time, it may be advisable for the man to indulge in 'moderate' kissing for shorter durations. He wryly adds that on subsequent occasions such moderation may be entirely unnecessary. Nevertheless, it is very important to read a woman's response correctly. If a man pulls a woman to himself and places his lips on hers, and she does not resist, but makes no response of her own, it would be unwise to interpret the kiss as anything but 'nominal'. His ardour must then take into account the woman's diffidence, inhibition, or uncertainty. If, on the other hand, the maiden moves her lower lip, and presses his lips slightly or quiveringly, he can (up)grade the kiss to 'throbbing'. If the tongue comes into play, the signal is qualitatively different. The eyes too need to be carefully watched. For instance, if the lady were to touch her lover's lip with her tongue, close her own eyes, and use her hands to pull him closer, she is performing well above par.

Creativity and imagination are the trump cards in this game. The most obvious position for a beginner would be the 'straight' kiss, wherein the lovers just bring their lips in contact while facing each other. However, there is no reason whatsoever for a man to be so predictably straightforward. Variation is not only feasible, it is greatly rewarding for the most part. Nothing prevents him from executing the 'slanting' kiss, in which he sensually rubs his lips diagonally against hers. He could as effectively hold her face in his hands, lift it up gently by the chin, and then plant a full-blown 'turned' kiss on her expectantly upturned lips. And he could do all of the above with varying pressure, not only on the lips as a whole but each lip separately. A 'pressed' kiss would result if he were to press the lower lip with deliberate but controlled force. If the mood is upon him, he could involve his fingers in the action. Vatsyayana suggests holding her lower lip between two fingers so that it forms the shape of an 'o', and then trace the tongue slowly along the circumference, before pressing forcefully with the lips.

Love-play is an integral part of good sex. They should be devised during the initial stage of dalliance, and be imaginatively improvised at each step subsequently. All lovers can kiss, but it is the good lover who can squeeze

the maximum enjoyment out of the act through the application of both technique and intelligence. Brain power during sex is demonstrated by the ability of a lover to explore intimacy in different ways, prolong the duration of congress, and enhance the quality of the experience by judicious additives of humour, play-acting and rivalry. To illustrate this, Vatsyayana recommends a mock contest between lovers during kissing. A wager could be laid as to who will first get to hold the lower lip of the other. A man could wisely lose the first round, and then demand that another round be played. Alternatively, he could win in the beginning and yield to the woman's insistence for another bet. Such passionate jousting can have a sensuously long duration. A woman who has lost can surprise her sleeping lover, days after the game was played, by seizing his lower lip again. Her claim to victory would then set off a new contest, and reignite passion.

The guru believes that lips are exceptionally malleable and versatile for the expression of love and passion. An accomplished lover should know how to use them to their fullest potential. A great many permutations are possible. A dashing man is encouraged to kiss a woman's upper lip, while giving to her only his lower lip. The daring man can try and hold both the lips of a woman in his own, and do so frontally, obliquely, or from any other angle that does not give him a painful crick. In such proceedings, he is welcome to make as much use of his tongue to press against her teeth, explore her palate, and engage her tongue in a friendly duel as long as she does not gag. Vatsyayana feels that a moustache could perhaps be a hindrance. Indeed, no man should take for granted a woman's preference for his hirsute upper lip. Some women seem to like getting more between their lips, and some certainly don't. A sensitive lover should be sharp as a razor to gauge such preferences. And if the lady would rather encounter lips without any accessories, he should not hesitate to make the ultimate sacrifice.

Any sacrifice is worth it when the art of kissing goes beyond the lips. Our guide says that there are different kinds of kisses for different parts of the body. Once a woman is prepared to receive them, a man should know where and when kissing should be 'moderate' and 'soft', where his lips would

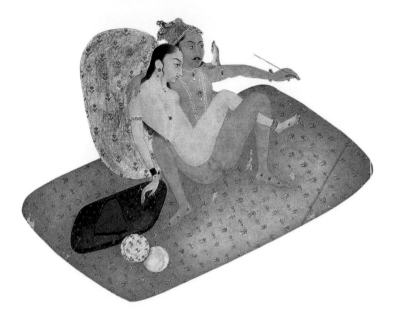

make the best contact if 'contracted', and where they need to just happily 'press' on. The ideal approach for a man is to do more of what she likes, and less of what she does not. Of course, sex is not a one-way street in which men do certain things to women, and women remain passive dummies. It is a multi-lane expressway in which women often convey much more to men. Men should have the sensitivity and the brains – and not just the testosterone – to respond appropriately. Vatsyayana gives examples to explain more. A woman can kiss a man while he is asleep, and when he awakes just look at him in a manner that silently conveys her desire to make love. It would definitely be inappropriate for him to then turn over and go to sleep again. On another occasion, a woman could kiss a man when he is busy working, when he is absorbed in listening to music or reading a book, or even when he is quarrelling with her or about to fall asleep. When this happens, a man would do himself a lot of good by getting his priorities, and her message, right.

As important as passion is the art of conveying it. If a lover returns home late, and the object of his desire has fallen asleep while waiting for him, he

would be well advised to kiss her as she sleeps, for in so doing he would simultaneously accomplish both an apology and an invitation. She may be feigning sleep, but even if this is so – and all the more if it is – he cannot go wrong in waking her. Sometimes he may be required to show ingenuity. For instance, he could convey his desire to kiss her by kissing her reflection in a mirror or in water, or her shadow on a wall. He could also 'transfer' a kiss by kissing a child in his lap in such a way that she is left in no doubt about what he would really like to do: dump the child and grab her.

Lovers can be artists, building on each other's creativity. But in whatever they do, they must, the guru reiterates in a read-my-lips tone, follow reciprocity. When a woman kisses a man, he should kiss her back. If he kisses her, she should do the same. Between consenting lovers a kiss is an invitation to newer and deeper pastures.

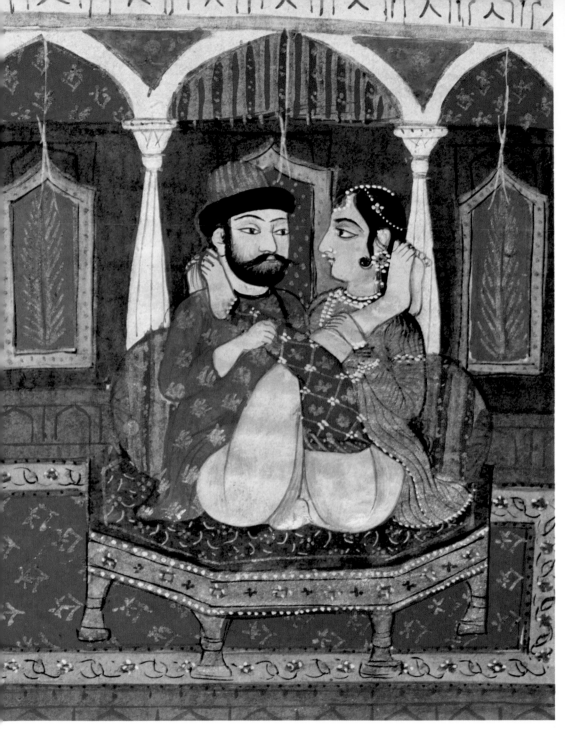

Maintaining variety in sex is the greatest challenge. It must never turn into a monotonous act.

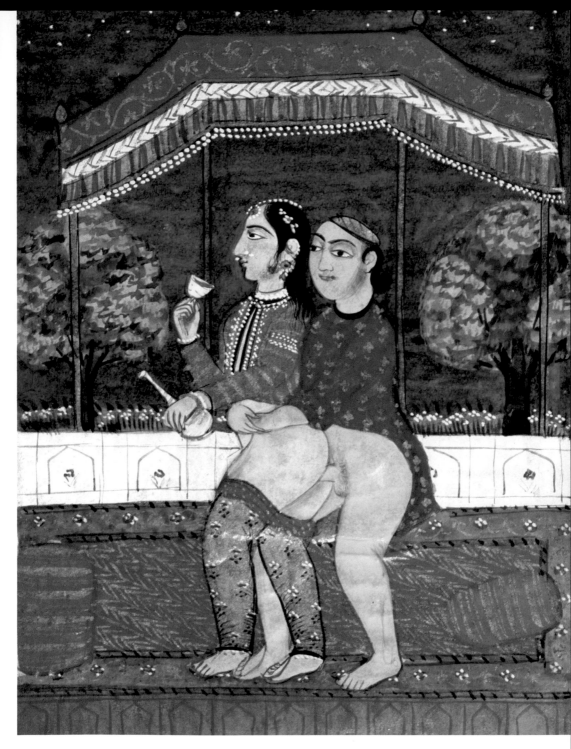

If a woman wants the man all to herself, she may very well use every trick in the book to keep him satisfied and wanting for more.

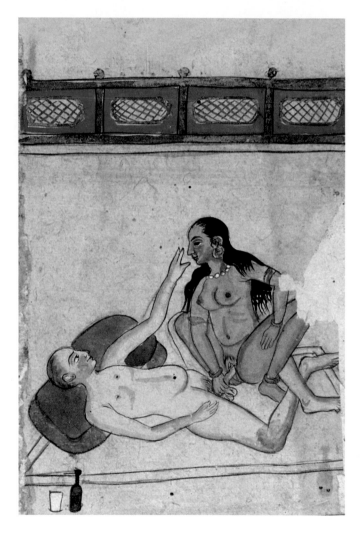

Once the man has climaxed, he usually lies down to rest, while the woman, still eager, may wish to continue.

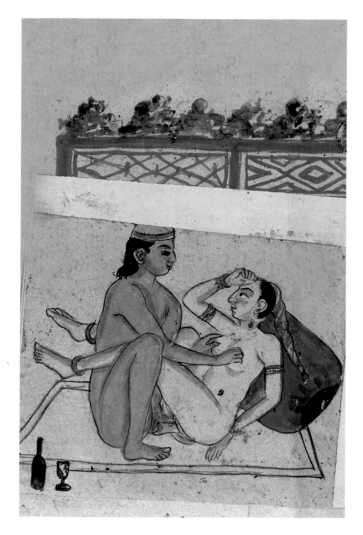

Nails should be used only when passion is extremely intense.

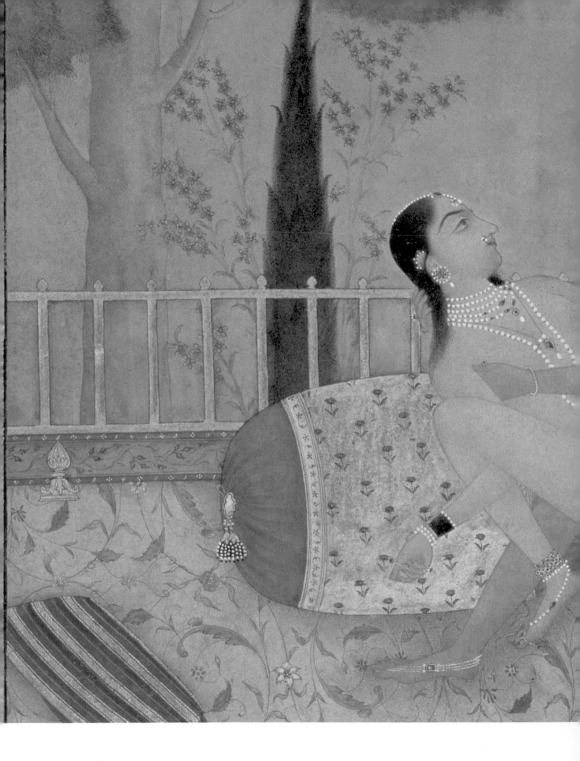

The point of climax during love is often compared to the spiritual union with God.

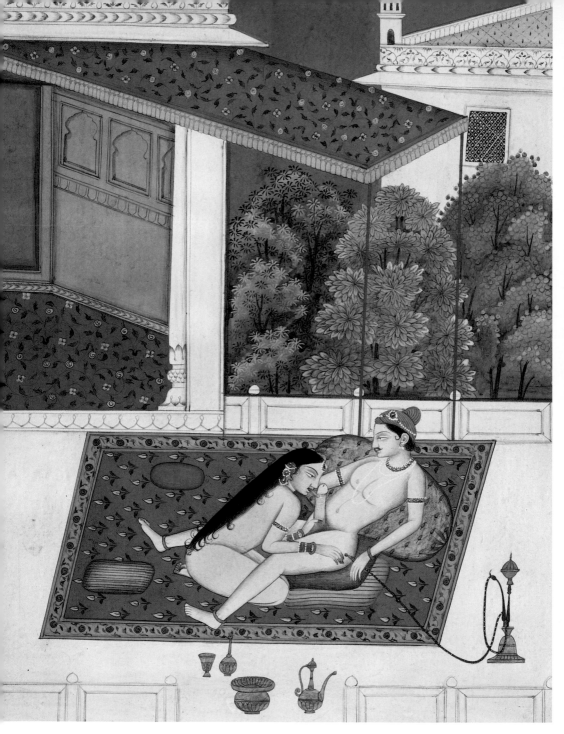

Foreplay is an essential part of the sexual experience.

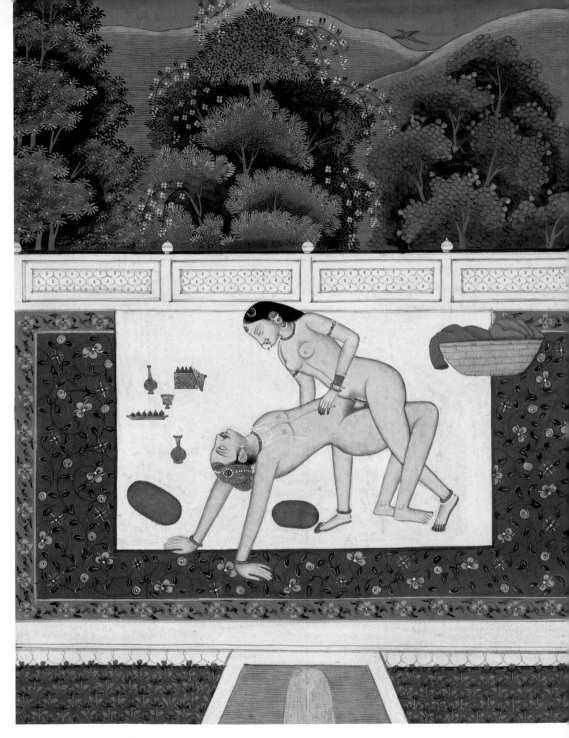

Mastering the postures of the Kama Sutra requires patience and practice.

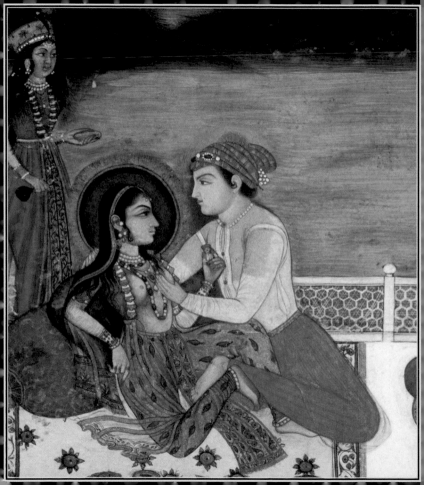

The Use
of Nails

*G*ood lovers should leave their mark, literally. Vatsyayana recommends the use of the nails to press or scratch during advanced love-play, but does so in a qualified manner, refusing to be nailed down on any mandatory practice. Claws should be brought into function only when passion is intense and both partners are 'full of lust'. A man would be well advised not to unsheathe them when his partner is not ready, because if he does she is likely to reach a doctor's table, not an orgasm. Such a note of caution is very relevant because men are capable of effortlessly making an ape of themselves, by actually believing that women ecstatically yield to the brutish physical onslaught of a macho man. Sometimes, yes; but mostly, no. Men do not reduce their physical appeal by being gentle; so if they must scratch below the surface, it is best that they do so at the right time, and, even more importantly, in the right way.

Vatsyayana suggests some specific occasions when nail marks would be in order: when a man is leaving home to undertake a journey; when he returns from a journey; when lovers make up after a fight; and when a woman is intoxicated. The first two suggestions need explanation. Our guru wrote at a time when journeys away from home were fraught with uncertainty and could take considerable time, during which there would be almost no communication between lovers. A lover made love on the eve of such a journey with the fervour of what could possibly be a final union, and sought to leave on his beloved a mark by which she could, in privacy, reconjure the moment of passion after their parting. It is difficult to give an exact parallel in our times to the bitter-sweet intensity of such a moment, but one situation that comes to mind is the departure of a soldier to the battlefront. The joy of reunion at the safe completion of such a mission is in direct proportion to the pain of separation that marks its beginning. Both occasions are moments of intense passion, and can be etched as such.

The simple point here is that nothing about making love can only be a matter of routine, and everything about it can be influenced by a special situation. Making up after a fight is a special moment. A lover is

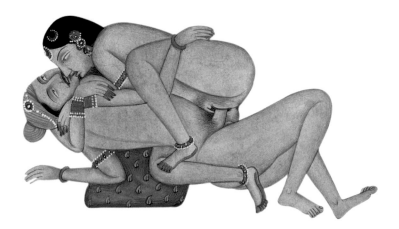

then moved to convey all the more passionately his renewed love and commitment, and his partner is willing to receive and reciprocate likewise. Vatsyayana encourages lovers to lose their sense of inhibition and restraint at such moments. It is possibly this notion that makes him cite an intoxicated woman. Such a woman is likely to be a more adventurous lover, and less disinclined to reject the aggressive expression of passion. Men should not infer from this that their primary task is to get a woman drunk; nor should they conclude that unless a woman is drunk, she would not welcome a mark of their ardour. The indication here is to moods, and the possibilities they open up, and not to iron-cast prescriptions or formulas.

If men want to use nails as an accessory in the 'battle' of love, they must learn how to maintain them. Our fastidious guide is explicit on the qualities of nails that make the grade. Firstly, they should be clean. Their use is meant to inflame passion, not create wounds that turn septic. Nails with cracks are not acceptable. Ideally, they should be smooth and whole, and well-set, with a flat, even surface, and not be excessively hard. They should look healthy and appear bright. That is not all. Vatsyayana recommends that nails can be specifically manicured to suit the level of passion. A man who thinks he is more passionate than most, should try to make two or three ridges on the nails of his left hand, like the blade of a saw. Those more modest about their abilities, can shape them like the beak of a parrot. And those who rate themselves a little below par, can grow them in the shape of a crescent.

If some readers are already making enquiries on how to train as a manicurist, they are counselled not to overreact. Vatsyayana's purpose is to make men look again at what they often take for granted. It is not enough to believe that any kind of nails will do, or that all nails are alike. To participate in the fine art of making love, nails need grooming and care. They need not always be like a saw-blade, a parrot's beak, or a perfect crescent, but they are required to be clean, glossy and healthy. If she likes the touch of a saw on her body, why not spend time with a manicurist to please her! Men need to

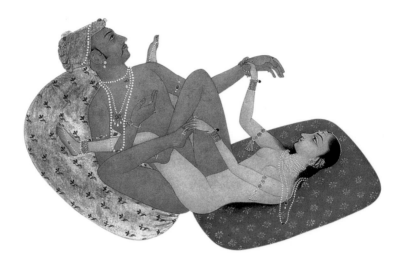

be rescued from their sense of complacency – and, alas, ignorance – in such matters. They do not need to become manicurists, but they can certainly try and maintain healthy nails.

Nail marks can be placed on any part of the body when passion is at its peak. However, the recommended areas for their use are the neck, the armpits, the breasts, the back, the posterior, the waist and the thighs. Vatsyayana details eight kinds of methods. In the first, the fingers are kept close together, and the nails are rubbed against the breasts or the thighs in such a way that no mark is made; only the hair on the body stands erect as a result of the pressure. As the pressure is applied, an audible sound can be made by rubbing the thumbnail against the other fingers. In the second, the nail tip of the middle finger is used to make a half-moon impression on the breasts or the neck. Crescents can be made opposite each other, thus forming a circle, and such a *mandala* best adorns the navel, the joints of the thighs, and the small depressions above the buttocks. A fourth option, and possibly the simplest, is to leave a straight line. This can be made on any part of the body, but should not be too long. Success in the simple actions can instil confidence to attempt the more complex. A line when

slightly curved and etched on the breast or the neck, becomes the 'tiger's nail'. A more difficult engraving is the 'peacock's foot'. Placing the thumb below and the fingers above the nipple, and squeezing gently but firmly, gives it form. The guru concedes that few men make the mark here. It requires great skill, but the upside is that it gives great pleasure to women, and hence, is definitely worth trying. Moreover, proficiency in this can lead a man to attempt the 'hare's foot', in which several peacock foots are inscribed close to each other near the nipples. The final picture resembles the leaping of a hare, and is much appreciated by an aroused woman. And lastly, there is the 'lotus leaf', which (as you have rightly guessed) should resemble the leaf of a lotus, and the right place to leave the imprint on is the breast or the waist.

Undoubtedly, many readers must now be feeling that Vatsyayana was in reality a master sculptor masquerading as an authority on love! But the guru redeems himself by hastening to stress that in spite of the intricate designs he recommends, there is no set method on how a man should use his nails. In the grip of passion each man is distinctive. Men will leave their mark in as many ways as there are women. The methods he describes should be seen – like it is with so many other instructions in his manual – as a guide. It should not, to borrow a phrase from another great helmsman, 'restrict the instinct to let a hundred flowers bloom,' provided, of course, that the season is right, the plough is clean, and the ground is yielding.

The guru adds a gentle warning: no man is a mark unto himself. If what he leaves etched on a woman is visible, he could be asked to take credit for his creativity. This is fine so long as the woman is not another man's wife, or the liaison is not in a category where the lovers need to be more discreet about the impact of the nail marks. In sounding a note of caution, Vatsyayana is only being pragmatic, not moralistic. In fact, even with another man's wife, he calmly suggests that the marks be placed where they are not so visible. If the woman can hide them, it is perfectly acceptable.

The enduring value of a nail impression is that it has the power to evoke the memory of a moment of great lust. Our mentor recalls another sloka:

When a woman sees the scars
that nails have made on her hidden places,
her love even for someone given up long ago
becomes as tender as if it were brand new.
When passions have been given up long ago,
love may disappear
unless there are wounds made by nails
to prompt memories of the abodes of passion.
Passion and respect arise
even in another man who sees,
from a distance, a young girl
with the mark of nails cut into her breasts.
And a man who is marked
with the signs of nails in various places
generally disturbs a woman's mind
no matter how firm it may be.
There are no keener means
of increasing passion
than acts inflicted
with tooth and nail.

(From the translation of the *Kama Sutra*
by Wendy Doniger and Sudhir Kakar)

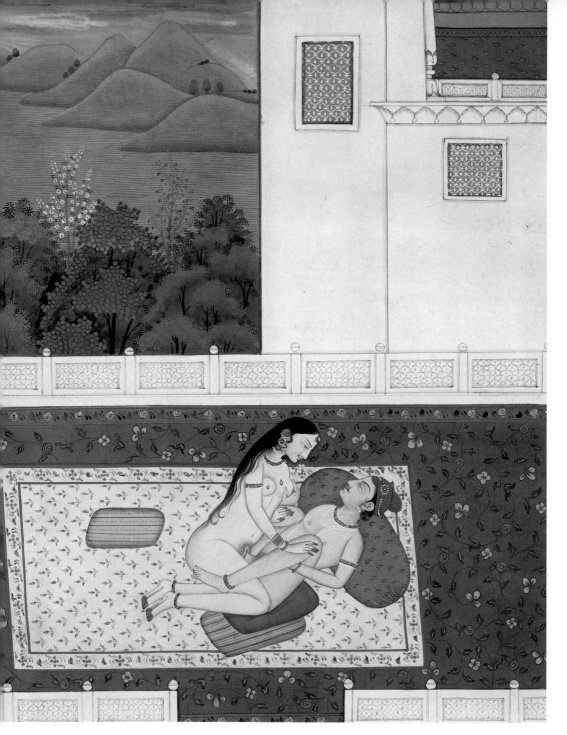

Even when sexual relations cease, true love between partners never dies.

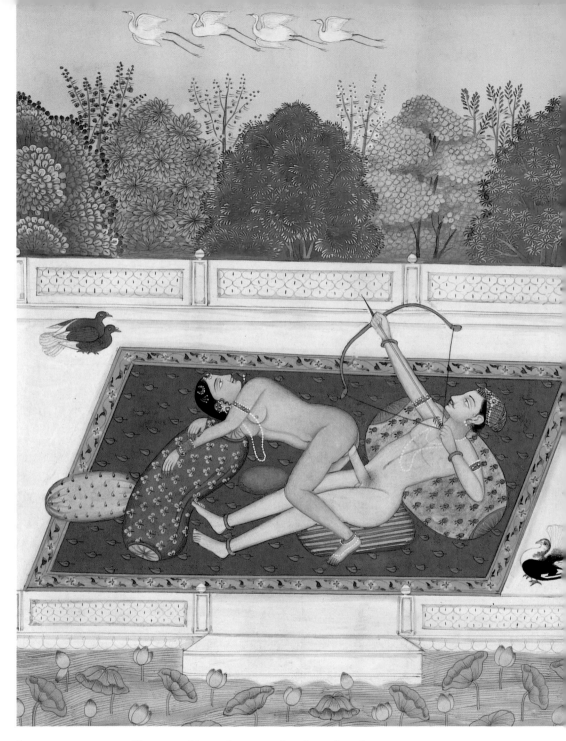

In ancient times, scenes of hunting and lovemaking were often depicted together.

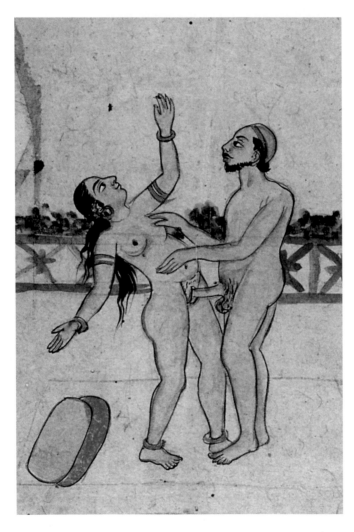

*At times, aping the movement of animals brings greater
pleasure during sex.*

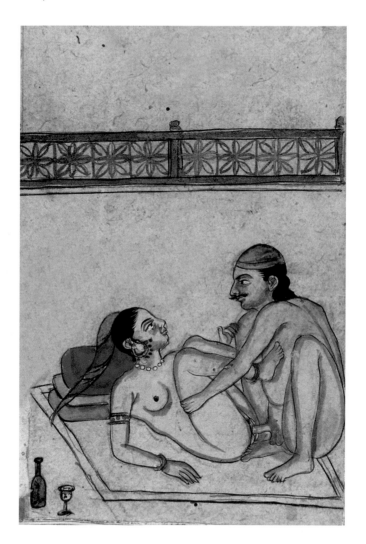

The basic right of both men and women is to climax during sexual intercourse, says Vatsyayana.

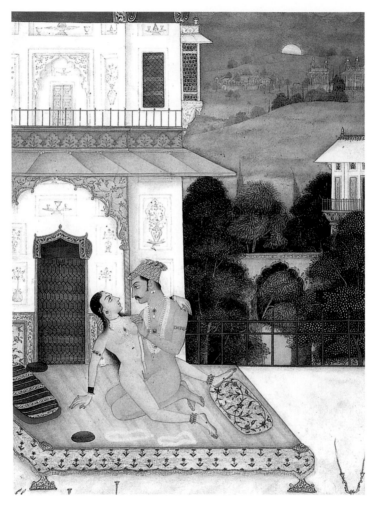

*The man who is 'long-timed' is held in high esteem by women,
since they take longer to climax.*

*Facing page: The more noise a woman makes, the more likely
it is that she is enjoying herself.*

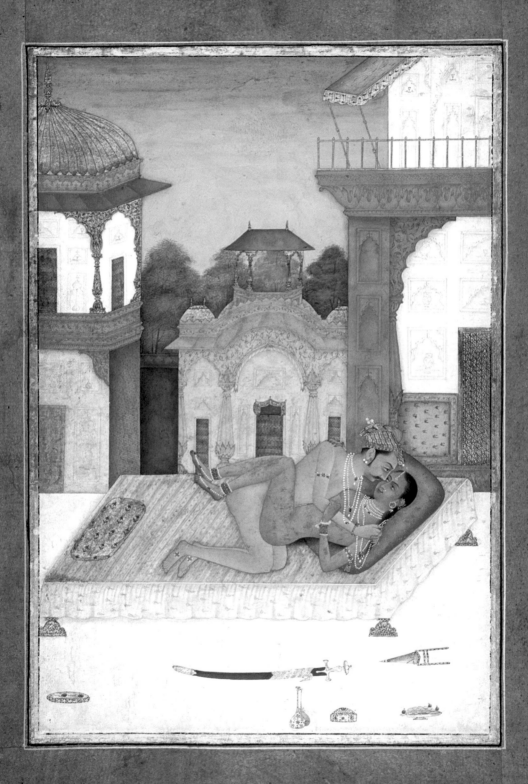

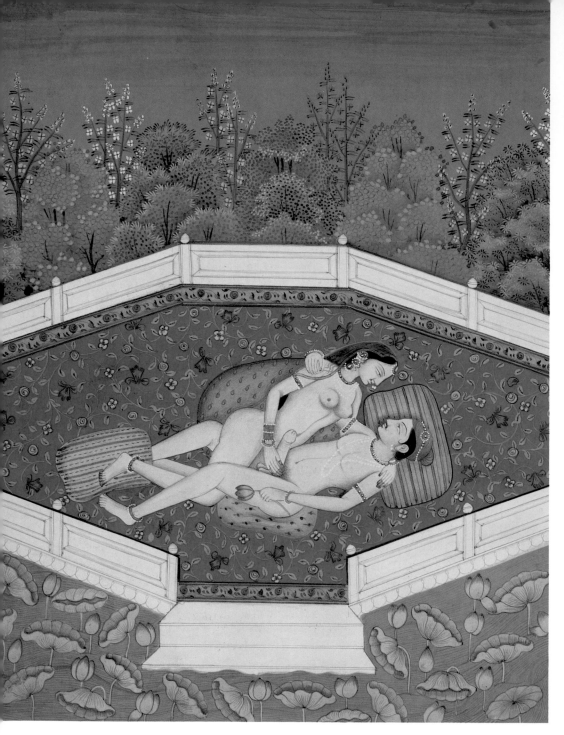

If a man has several wives, none is to be neglected;
each one must be given her due importance.

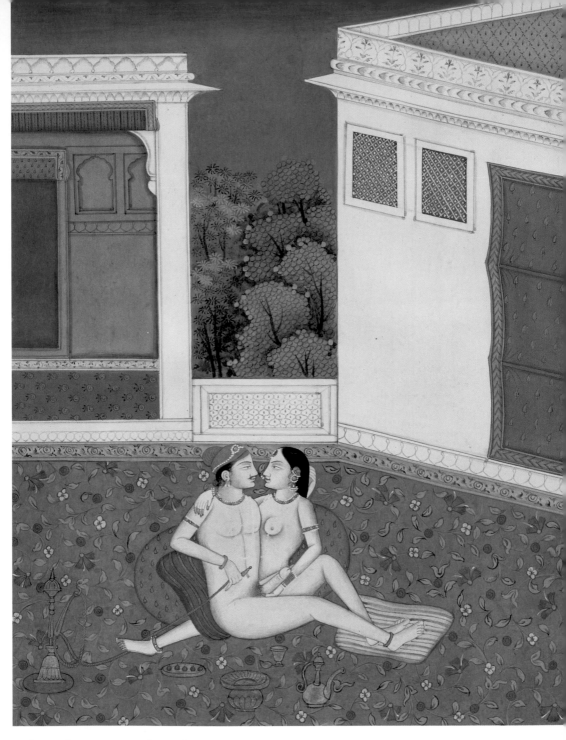

A change of setting is essential to combat monotony.

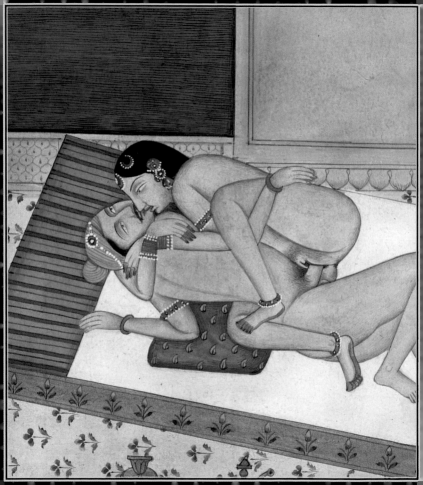

The Bite

*G*ood sex is about the fullest use of every part of the body in the pursuit of pleasure. If nails can scratch, teeth can bite. Vatsyayana recommends the use of both. However, as with nails, his first concern is with quality. Any kind of teeth will not do. To qualify for use in the armoury of love, teeth must have the right attributes. They should be even, unbroken, closely set, and bright, with sharp edges. They should not be rough, protruding, blunt, too large, or loosely set. This is not a matter of aesthetics alone, although a good-looking and clean set of teeth is more likely to find welcoming flesh. There is also a question of practicality. Bad teeth are likely to make bad indentations. A blunt set of molars may impress less and hurt more. Rough edges may cause more pain than pleasure. A man may have to pay dearly for biting off more than he can chew. **A badly bitten woman, he should remember, will have her reservations.** If your teeth are not up to the mark, do not use them, advises our guru.

If the teeth pass muster, they can be used in all the places where a woman can be kissed, with the exception of the upper lip, the inside of the mouth, and the eyes. The last two prohibitions are easy to understand. It may be too high a price to pay for a man's passion, should the lady be rendered both blind and speechless. Why the upper lip is out of bounds for the molars is not entirely clear, but perhaps the lower lip is, physically, a more delectable morsel.

'Eight' seems to be a favourite number with the master. If he spoke of eight ways to put nails to good use, he has a similar number for the effective use of teeth. When the teeth do not bite, but only produce redness on the skin, they indicate a 'hidden bite'. This would appear to be a good way to test the waters – or taste the woman, to be more precise. If this mild attack is not found repulsive, the 'hidden bite' can be applied with greater force, pressing the skin on both sides, to create the 'swollen bite'. When only two teeth are used to bite a small area of the skin, they create a *bindu*, or a point. When all the teeth are used on such a small patch, they create a 'line of points'. If the woman is not convinced by now that her lover is a carnivore

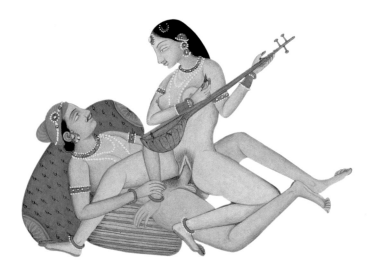

on the loose, the 'swollen bite' can be attempted on the cheeks, by using the upper teeth and the lower lip in such a way that a red mark is created, and not – thank goodness – a permanent scar. This is called 'the coral and the jewel.' A series of red marks makes a 'line of jewels'. A circle on the breasts, formed by using all the teeth and specially the spaces between them, is called, evocatively enough, the 'broken cloud.' The final variant drops all pretence of restraint. It is called the 'biting of a boar', and is produced on the breasts and shoulders by using all the teeth to create broad rows of marks interspersed with reddish welts.

Before acquiring a cutting edge, men would do well to heed Vatsyayana's consistent advice: do only that which is agreeable to a woman. If a woman is uncomfortable at being bitten, it is foolish to persist in 'impressing' her. Equally, if one woman prefers an unblemished skin, it is wrong to infer that all women do. As we have emphasised earlier, each woman has her own code of pleasure, and a good lover is judged by his ability to decipher it and respect it.

Aware of the special importance of respecting a woman's preference in the matter of the bite, Vatsyayana takes us on a little journey to explicate how women can be drastically different in what pleases them. Women of the region between the Ganga and the Jamuna do not like such 'lusty practices', he informs. Those of Baluchistan like to be physically struck by their lovers. The women of Maharashtra like their men to use foul language while making love. Those of Patna and Pataliputra are more demure. In Tamil Nadu the women like to be 'rubbed' and 'pressed'. Men who use vulgar language are abhorrent to the women of Vanavasi, but they are not averse to the enjoyments of sex and know how to cover their love marks with adroitness. The women of Avanti not only do not like men who use nails and teeth, they are also averse to kissing. The fair ones of Malwa are relatively amenable. Those hailing from Abhira, and the region of the Punjab, can be won over by oral sex. The women of Aparanta and Lat are very passionate and very vocal while making love. In Kosala and Oudh, the women are impetuous in their desires; they are also adept in making love potions. Those of Andhra are

voluptuous in their tastes; and the women of Gauda are notable mostly for their sweet tongues.

One wonders how the guru came to such precise conclusions about the intimate sexual likes and dislikes of women spread over an area almost as large as present-day India. Did he do the field research himself? Did he depend on research assistants? Did the women confide their innermost fantasies to him? How many 'encounters' must it have taken for such observations to crystallise? Were there earlier region-specific texts dwelling on the intimate preferences of women? We do not have the answers, but it would be fair to assume that, prior to his year of celibacy, our mentor had little option but to mix business with pleasure. And perhaps his decision to be celibate had as much to do with resolve, as with the simple fact that he had had quite enough for some time to come.

Were Vatsyayana's observations accurate? Was his research methodology right? Was his sample size large enough? Such unanswered questions should not make us lose sight of what he wanted to prove, namely, that women differ in what turns them on. In fact, if we must disagree with him, we can

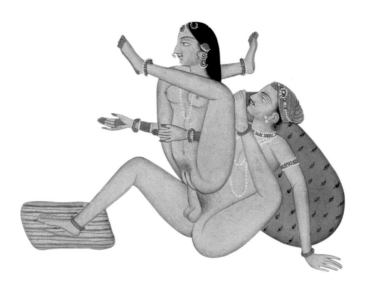

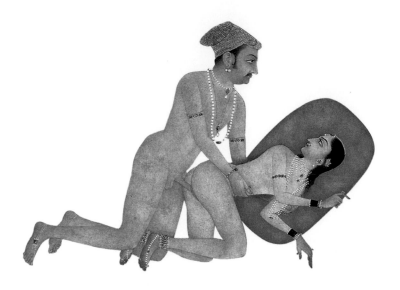

question his classification of women by regions. Women of a certain region may have certain similarities in their carnal preferences, but even within a region – and, indeed, within a much smaller social unit like the family – women can vary in what they want their lovers to do, and such a choice must be both respected and, wherever possible, fulfilled.

Men should, therefore, look before they bite. If she appears to like the incisive touch, it is time to take the bit by the teeth and put the enamel to pleasurable use. Technique is important. Love can be more than skin-deep, but its evidence in this respect is best kept superficial. As with the use of nails, there is always scope for human ingenuity, but up to a point. A woman's body is not a palette for a man to experiment with as he pleases. The illustrations provided by Vatsyayana merit careful study, for they have been tested to enable the expression of 'dental' passion in a variety of ways, within the limits of tolerance of a willing woman. They may appear difficult to emulate, but – once the teething stage is over, as it were – their technique can certainly be mastered, bit-by-bit of course.

A man who, consumed by passion, is happily engaged in using his teeth, should not be surprised if she too would like to return the favour. He should not balk if she bestows a 'swollen bite' for every 'hidden' one, or gives him

an artistic 'coral and the jewel' for every 'line of points' received. The practice of love is one of democratic equality. There is no weaker sex in this game. 'A man who persists in carving a woman with his nails and teeth even when she resists, should be bitten by her with double the force,' says Vatsyayana. There is no need for her to be a passive chunk of meat to his molar ministrations. A woman who does not give as good as she gets, receives a red mark in the guru's performance sheet.

And yet, this is not a matter of one-upmanship. In the ideal setting, biting should, at worst, lead to a simulated lovers' quarrel, not acrimony leaving both sides bruised. A man should bite in the effortless overflow of desire, so that he may arouse his beloved to even greater heights of ardour. In this context, even if slightly hurt, she will not be angry. On the contrary, she may pick a delightful lovers' quarrel guaranteed to give their love-play a nail-biting finish. Our omniscient guide has advice on how exactly she can do this:

> *At such a time she should grab her lover by the hair, and bend his head down, and drink from his mouth, and then, being intoxicated with love, she should shut her eyes and bite him here and there.*

Which man can resist the sheer seduction of such an eventuality?

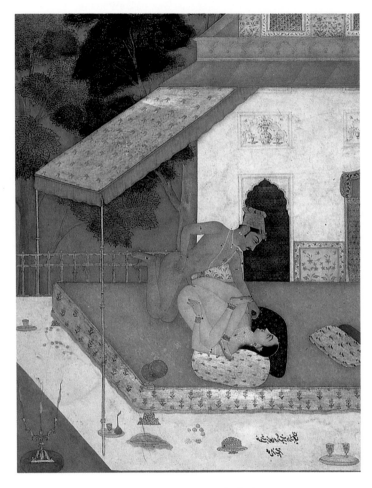

If a woman is violently assaulted, she is averse to any signs
of affection. Men must learn the gentle art of seduction.

Facing page: Vatsyayana encourages partners
to remain faithful to each other.

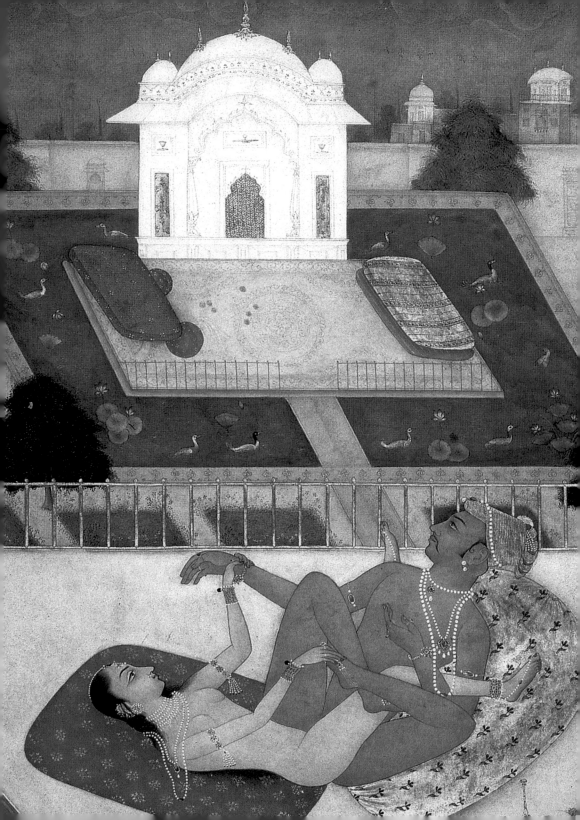

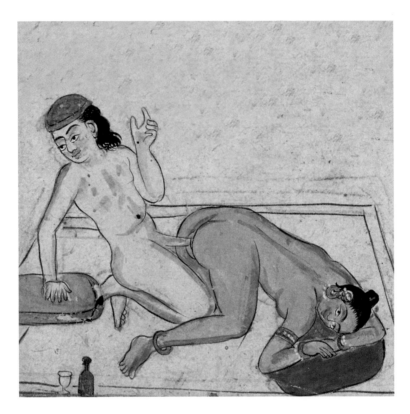

'Congress of the cow' is when the woman gets down on her
hands and feet, and her lover mounts her like a bull.

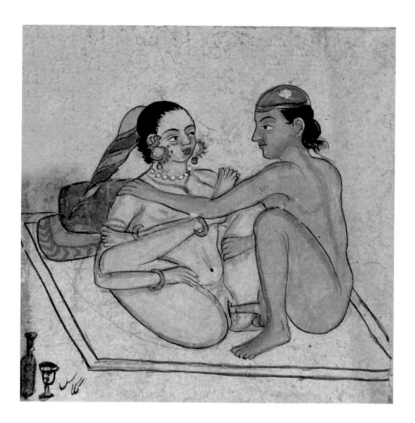

Some postures require props: a pillow, a tree, or a wall.

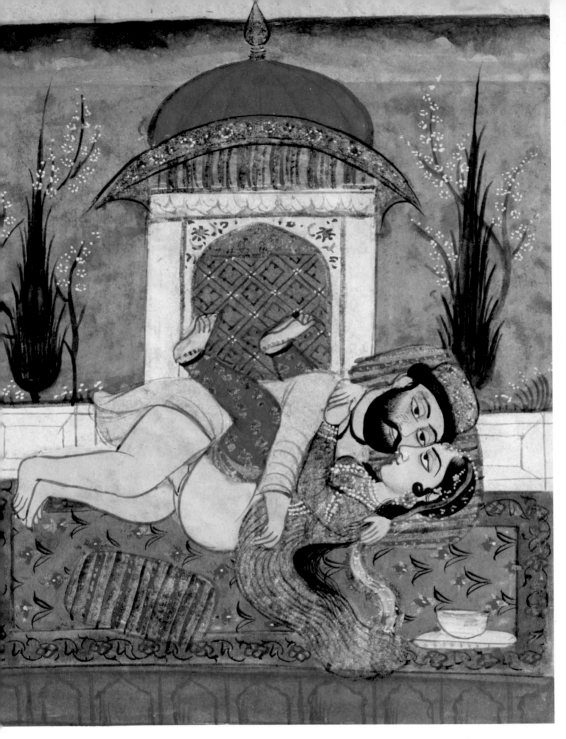

Discipline of the body, mind and spirit is essential, says Vatsyayana.

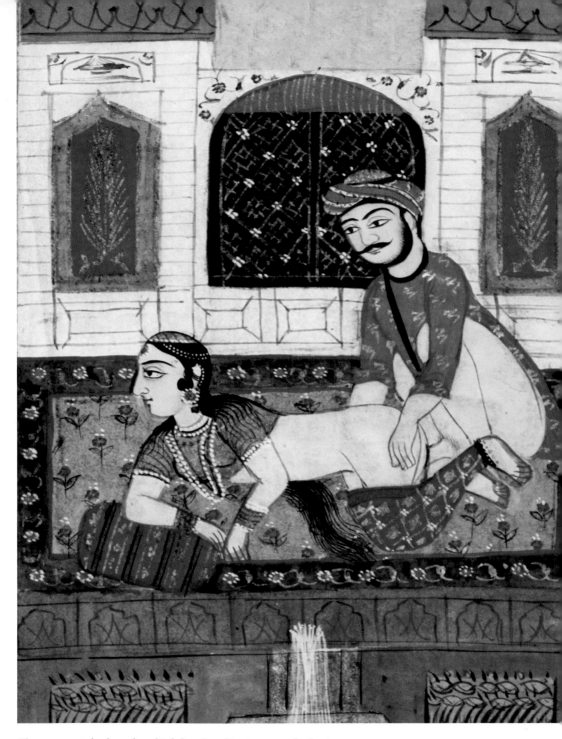

The man must slowly undress his beloved, making it an act of seduction.

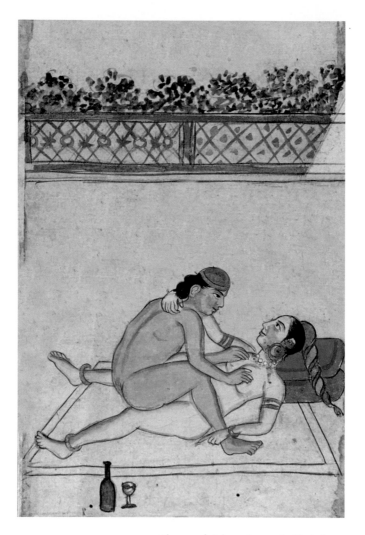

The use of violence is permissible in love.
Vatsyayana, however, warns against excess.

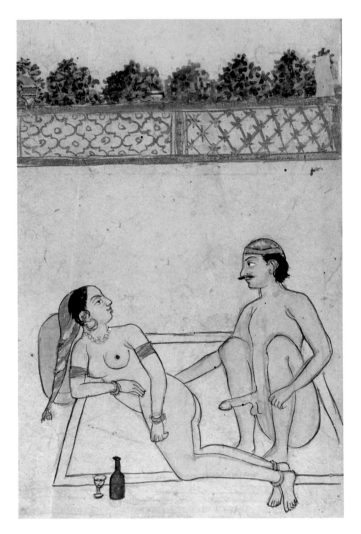

Making up after quarrels can very often take lovers
to new levels of pleasure.

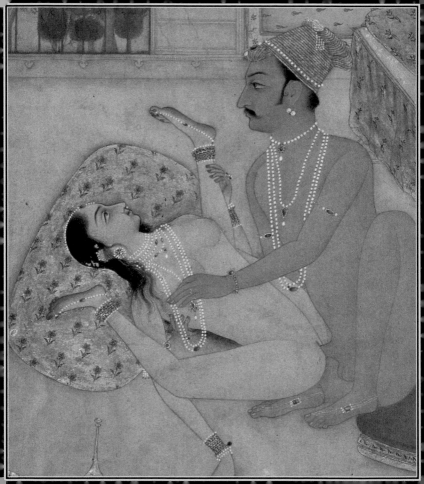

The Use
of Violence

*A*t the height of passion, Vatsyayana permits a mild form of sadism. Sexual intercourse, he says, is a kind of battle, a combat – where two (hopefully) skilled players find spontaneously aggressive means of expressing their fervour. Such expressions are mutually arousing, and can reach a culmination where the two lovers become oblivious to the force used and, sometimes, even to the physical pain they are causing each other.

For such an attack to not end up as a case of homicide, men must know how much force to use, how to use it, and where best to apply it. They may want to appear 'striking', but they must know when to stop, and heed the lady if she is desperately trying to convey that it is 'enough' already.

There is no barometer to precisely measure how much force a man can use when in the throes of passion. The only foolproof indication is to see how the woman is reacting. If she is moaning with pleasure, being driven to other audible sounds of obvious approval, or willing to indulge in a bit of 'thrashing'

herself, then the force is within acceptable and pleasurable limits. If she is lying limp or screaming in pain, then she is either beyond help, or beyond pleasure, or beyond both. The real danger arises if the man is so absorbed with his own pleasure to not notice whether his partner has, in fact, passed out. Our guru considers such a possibility to be real, and must be felicitated for his accurate insight into the behavioural pattern of his own species. His words of caution have a deadly ring to them. He recalls that the ruler of Pancala killed the courtesan Madhavsena by the intensity of his erotic grip. Queen Malayawati became a victim to the passionate scissor-like grip of her husband, the king of the Satavahanas. And Naradeva blinded the woman he lusted for, by hitting her eye instead of her cheek.

Men, in moments of sexual frenzy, have not been known to be good marksmen. Perhaps Naradeva's victim forgave him for missing his aim. Or, perhaps she spent the rest of her life silently wanting an eye for an eye. There is little doubt, though, that the modern woman shall neither forgive nor suffer in silence. And any man who is more violent than he should be, will likely learn the hard way.

Having said that, careful lovers can find it most rewarding to thrash each other a little. Vatsyayana spells out the technique. Any part of the body can be struck, but the places of special importance are the head, the shoulders, the space between the breasts, the back, the sides and the middle parts. There are four recommended ways to strike: with the back of the hand, with the open palm, with the hollow of the palm and with the fist. The use of the fist is in order when the woman is sitting on the man's lap. On such a happy occasion, her back is a good spot for punching practice. During sexual union the space between the breasts is the right area to concentrate on. The guru suggests that the breasts should be fondled, even as the space between them is being attacked. This hit-and-fondle activity should begin slowly, but pick up pace as excitement increases, and should not cease until orgasm. The sides and the middle are good attack zones toward the end of congress.

A woman caught on the 'beaten' track can face other kinds of attacks, too. Her lover can form a scissor-like grip on her head, or use his hands to form a

wedge between her breasts. If his fingers are feeling left out, they can be used to pierce her cheeks. Pressure similar to a pincer can also be applied to her sides, and, of course, on her breasts.

Vatsyayana does not appear to approve of these practices. Much to the relief of most women, he is of the view that they could cause excessive pain. Some women may like to be strangled, and some men may know the art of creative restraint, but in general such violence is a trifle barbaric and not worthy of imitation. The guru's personal favourite as a weapon of aggression seems to be the hollow of the palm. Its use is designed to ensure maximum noise and minimum pain – a good combination for the woman who is not averse to being struck in love, but does not wish to be carried out on a stretcher.

Understanding what a woman is trying to say through the sounds she makes while making love, should be known to a man, particularly if some physical playfulness is likely to be included in the love play. Men know that women use their vocal cords far more while making love. The male rule of thumb is that the more noise a woman is making, the more she is enjoying herself. It is not an entirely wrong assumption, and a man can be forgiven for not knowing whether to feel embarrassed or happy if the neighbours complain about the high-pitched decibel levels emanating from the bedroom.

To such simplistic understanding, Vatsyayana adds several important nuances. A woman can shriek, hiss, or croon in ecstasy. She can also purr, coo, whimper, gasp, moan, sob and make sounds that resemble – doff your hats to our great mentor – the 'splitting of a bamboo' and the 'fall of a berry in water'. She can do all of these in several ways. Unaware of her own talents she can also make sounds similar to those of a dove, a cuckoo, a pigeon, a parrot, a bee, a sparrow, a duck, and a quail, and that too without any predictability of sequence. In moments of passionate clarity, she may also utter complete words, such as 'O, Mother!' and 'O, God!'.

All that inchoate articulation can be music to a man's ears. It may even ignite a new interest in ornithology. However, it could sometimes also be sounds without sense. The guru warns that any of these emissions could be an

expression of satisfaction, praise, or pain. In other words, when he hears his beloved making sounds like a parrot, she could be (a) delirious with joy, (b) about to die, (c) wanting a change in grip, (d) seeking less of the same, (e) wanting more of the same, (f) in unbearable pain, or (g) just angry at the unbelievable clumsiness of her lover. It would appear that a good lover must develop the canniness of an interpreter, who is required to translate correctly even though he does not speak or know the language in question.

Our guide smilingly assures us not to get worried. These comprehensive skills are mostly learnt instinctively. Most men know when they are giving pleasure to a woman, and if they don't, it is unlikely that they ever will. It is important, though, to gradually hone interpretational skills. When violence is in play, an error in understanding can make passion unbearable. The critical factor is whether the woman is enjoying the physical excess. If she is, her simulated exclamations of protest are like *ghee* poured into the fire of passion. His hits and her moans create an intensity that is quite unbeaten among the pleasures of sex.

Men need not be worried by the occasional impulse to mild violence when greatly aroused, says Vatsyayana. They are not deviants or weirdos if they nurse such desires. Some sort of sadism, acceptable to both parties, is a highly favourable aspect of sexual interaction. In sane persons such inclinations do not last long, and the normal state is quickly resumed. Men are expected to hit more than they are thrashed, but women are also encouraged to use their fists and hands. In general, women do better in this game by feigning to be helpless and vulnerable, while men act out a macho and impetuous role. The important thing is not to get carried away by the role-play. Men always need to remember that while they can be more 'forceful' lovers, occasionally women 'beat' them in the long run.

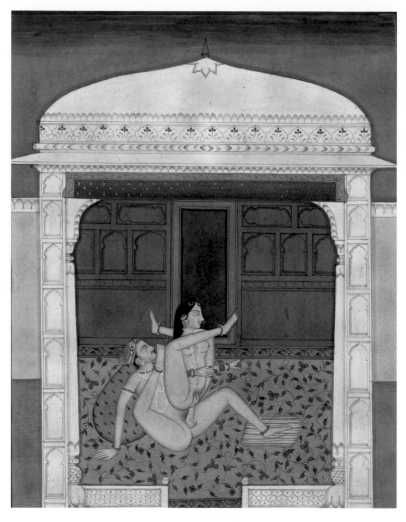

*Scenes of lovemaking can vary from jungles, gardens
and picnic spots, to terraces and balconies.*

*Facing page: Group sex is acceptable among
consenting participants, says Vatsyayana.*

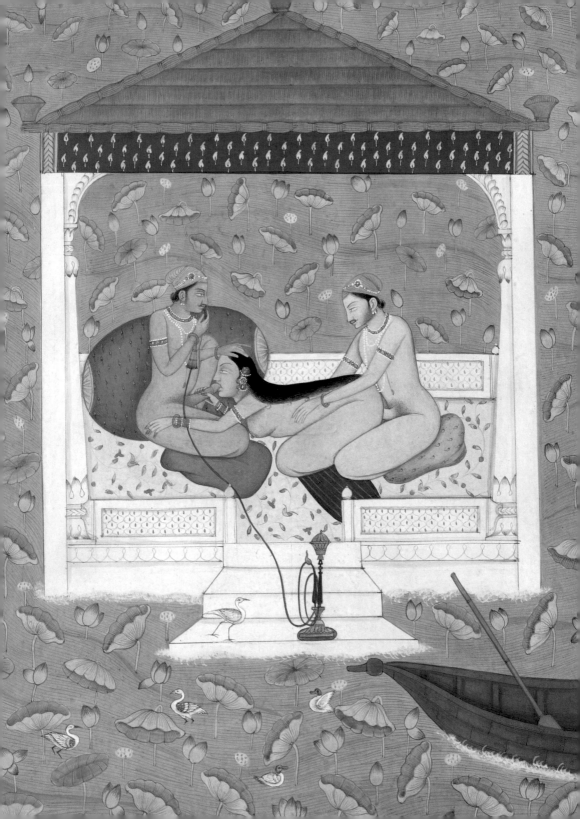

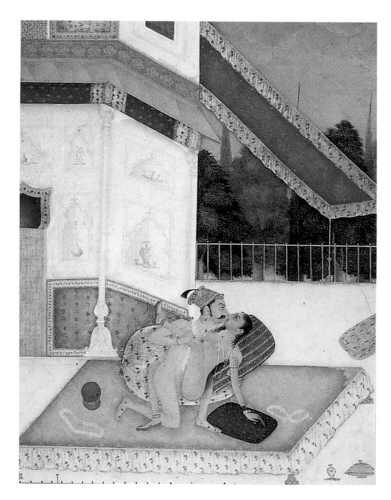

Vatsyayana emphasised the importance of hygiene.
He recommended the use of scented oils.

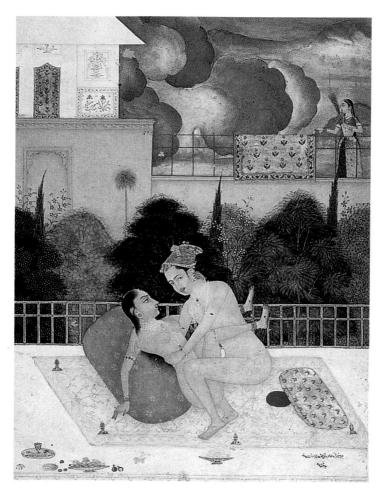

*At night, a man begins amorous games by gently
kissing his lover's hands and feet.*

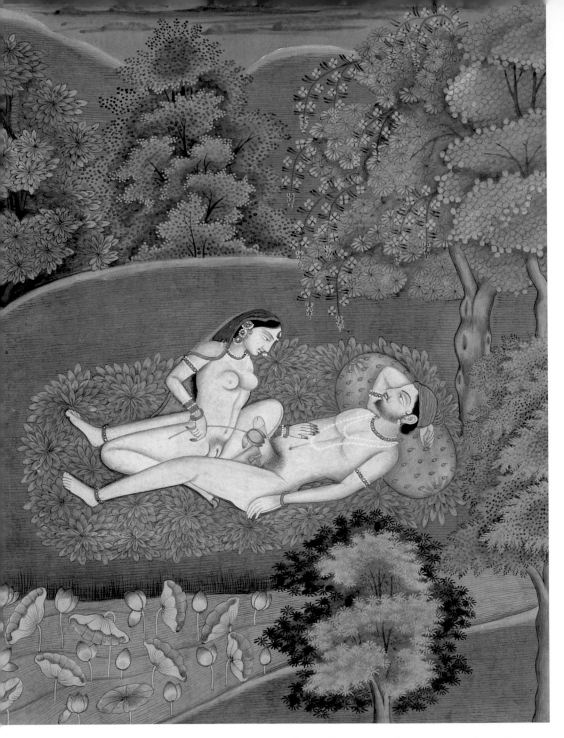

Gentle stimulation can awake strong sexual desires in a man.

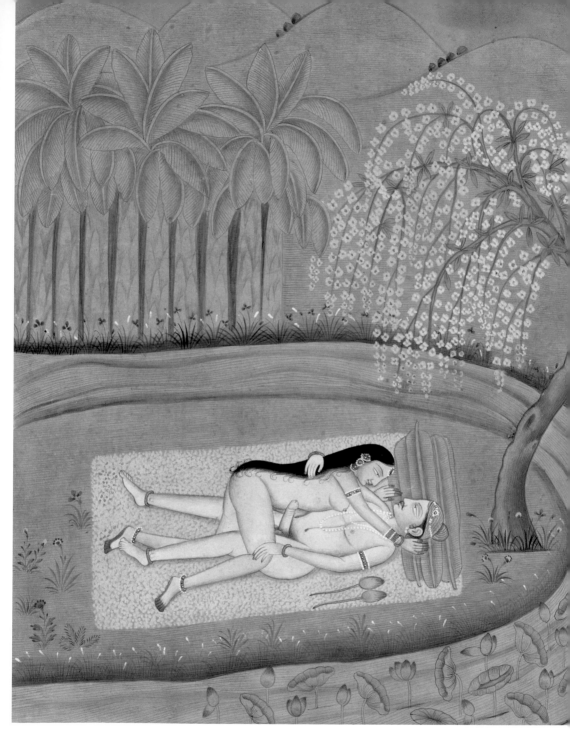

When the man is tired, the woman should let him rest by straddling him. However,
Vatsyayana warns heavy-set women to abstain from this form of coition.

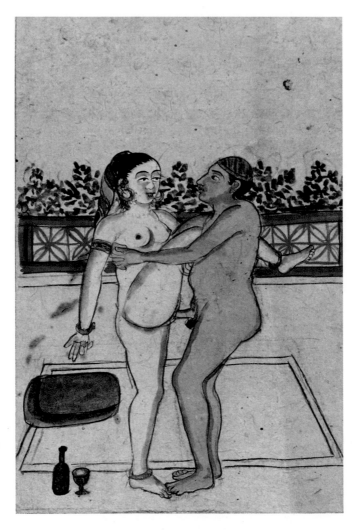

Women play a crucial role in prolonging the act of love.

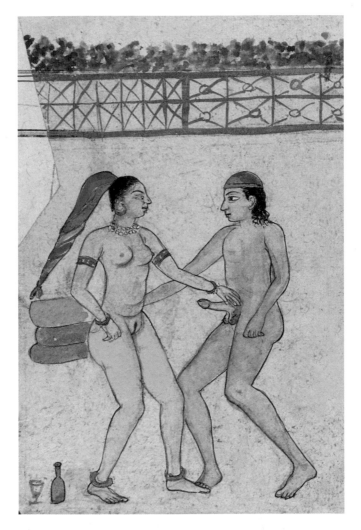

The favoured places to strike are the shoulders, the back, the head, the middle parts, and the area between the breasts.

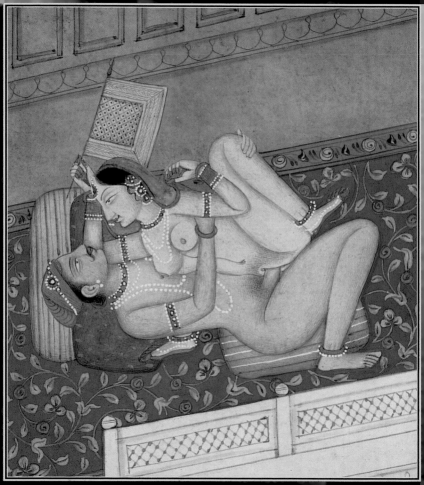

The Act
of Congress

*H*aving learnt how to embrace, kiss, scratch, bite and hit, we are now ready to learn how to derive optimum pleasure from the actual act of congress. Vatsyayana's premise is that the glory of the act lies in its variety. A man may have only one *lingam*, and a woman, only one *yoni*, but the manner in which they can be brought together are manifold. A good lover must know this, so as not to consign his sex life to the common dustbin of predictability and monotony. He who knows, must know and practice in many different ways. He must be willing to experiment. He must be prepared to exercise and provide choice. He must rebel against the tyranny of the one-dimensional. He must give full rein to his imagination. And he must marvel at the possibilities that open up when the body is supple and in shape.

Most men are inclined to think they are the prime movers in the act. The truth is that the woman can very often determine how a man moves, or even if he moves at all. The efficacy of a man's straightforward approach is

conditioned by the angle, posture and manner in which a woman receives it, and what she does with it subsequently. She could welcome it in the 'widely opened' position, lying on her back with her hips raised as high as possible; she could raise her thighs and keep them apart to create the 'yawning' position; she could be in the 'clasping' position, allowing the man to stretch out straight over her; she could cross her thigh over that of her lover to make a 'twining' position; she could raise both her thighs straight up to form the 'rising' position.

If a man has begun to feel a bit like a guided missile already, there are many more twists and turns in this launch. A woman moves her body and limbs to maximise pleasure. Such movements are beyond exhaustive enumeration, but some examples would suffice. She could, for instance, raise her legs and place them on her lover's shoulder, in a variation of the 'yawning' position; she could flex her legs so that they are pressed down by his chest; she could put one leg on his shoulder and stretch out the other to imitate the 'splitting of a bamboo'; she can twine one leg around his head to resemble the 'fixing of a nail'; she could become a 'crab' by contracting her legs; or she could cross her thighs to recall the 'lotus' position.

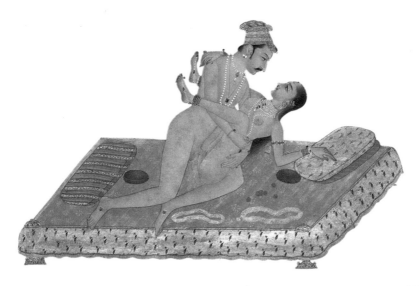

What must a man do in the midst of such gymnastics? He must drive her to greater versatility, assist her, and, of course, keep up with her. A woman does not need a dispassionate spectator to marvel at her contortions. She needs a participant who is as enthusiastic about getting some wholesome exercise. A variation to the missionary position must be the creation of both parties. Thus, for example, a man would do well to put her leg on his shoulder to pursue the 'yawning' position; he would do well if he raises her thighs to effect the 'rising' position; and he would demonstrate his willingness to sacrifice his life if he encourages her to twine her leg around his head. However, she would certainly not appreciate it if he bends her legs back so that they are pressed by his chest when he mounts her.

Vatsyayana cites some other postures where the role of a man is quite literally pivotal. In one particularly life-threatening position, the man, supporting himself against a wall, is supposed to hold up a woman sitting on his hands, while she moves sideways in congress by pushing herself against the wall. Since many men would prefer to be celibate for life than perform such load-bearing antics, it is important to try and understand the philosophy underlying the enumeration of such difficult postures. My view is that the guru described them more for inspiration than for imitation. His primary aim was to convey that the act of congress is capable of great heroic variations. Some require no effort. Others require practice. All provide pleasure. More importantly, they help the act to reinvent itself. They help pleasure to multiply. Their purpose is not to daunt, but to whet the appetite, and to help lovers to experiment in more creative ways.

Moreover, the more difficult the posture, the more it emphasises the importance of equal participation. If one party lies limp, sex is a let-down. It is not necessary that both participate in exact measure in all postures. Such mechanical notions of equality are redundant in the art of making love. Simply put, both must be partners in the common goal of sensual pleasure. The versatility of women, and their ability – often latent, or even unknown – to become such incredibly flexible instruments of love, is a must-know for every man. Any notion that they are passive receptacles for him to quickly

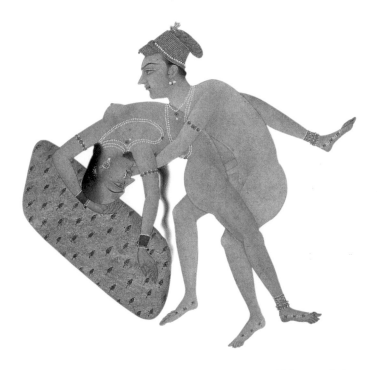

spend his passion, is repugnant to Vatsyayana. It would be much better for men to pull up their socks and strive to equal the mentor's expectations, rather than use the difficult postures as an excuse to be flabby and unenergetic lovers. Of course, by delineating so many variations, the guru is also highlighting the need for men to have the requisite staying power. The 'widely opened' option does little good to either party if the man has, by then, already closed his own.

A man must not only respond to a woman; he must, when necessary, prepare her to react. If the woman is not fully ready for intercourse, he should use his fingers to soften her vagina. Vatsyayana suggests he rub her vagina with his fingers and hand in the same way that an elephant rubs its trunk against an object, and should continue thus as long as she wants, and until her vagina is moist and quivering. Once his penis enters her, he can move in several ways. He can direct it upwards or press it down. He can use it to rub only one side of the vagina, like the 'biting of a boar,' or rub both sides, similar to the 'blow of a bull.' He can enter with great force,

or let himself in gently. He can move up and down rhythmically, without withdrawing – recalling the 'sporting of a sparrow,' or just keep it pressed inside. He can hold the penis in his hand and turn it around in the *yoni* to create a churning motion. He can mount a woman from behind by getting down on all fours, to approximate the 'congress of a cow and a bull.' If he gets carried away, he can also copulate in ways reminiscent of a dog, a deer, a goat, a donkey, a cat, a tiger, an elephant, a boar, a horse, and so on.

In all of this, Vatsyayana urges a man to only do what is pleasing to his partner. This requires him to be less absorbed in his own dexterity, and more in observing her responses. For instance, if she is bullish about being a cow, the choice is hers. If she is not, there is little reason for a man to continue on all fours like an ass. The guru's command is emphatic: 'A man should gather from the actions of the woman what disposition she is of, and in what way she likes to be enjoyed.' Concern for her satisfaction should make him rub his penis against that part of the vagina which makes her 'roll her eyes' in delight. Obviously, our master was aware of the clitoris and the G-spot. Part of the expertise is to recognise a woman's expressions of enjoyment and satisfaction. Vatsyayana lists these with the precision of a scientist. If a woman closes her eyes, loses all inhibitions, strives to bring the organs as close to each other as possible, and allows her body to go limp at the end of it all, she has probably had a fulfilling time. If she does not allow the man to get up, kicks him, bites him, looks upset, and continues to gyrate even after the man has climaxed, the reverse is true. In the not-so-uncommon possibility of the latter, the man could put his fingers and tongue to work.

Among the supreme pleasures a man can obtain, and give, is through the reversal of roles, where the woman assumes the role of the man and mounts him. Vatsyayana feels this happens best when a woman, aware that her partner has not yet climaxed but is tired by the act of copulation, comes on top to allow him rest from his exertions and facilitate her own orgasm. A man should know how to help in effecting this reversal. A woman could want to

turn around and move on top without a break in congress. She will be unable to do this if he does not show the required agility. Once on top, she could hold his penis inside like a 'pair of tongs'; she could move in circles like the 'spinning of a top'; or she could swing her abdomen and thighs sideways to approximate a 'swing'. He may wish to just lie back and enjoy this activity, but he should not forget to lift his thighs, whenever required, to assist her movements. Here, Vatsyayana adds a note of caution. However enjoyable the reversed position, it may not be advisable if a woman has delivered recently, is in the midst of her periods, or is too fat; otherwise, the situation could be life-threatening.

Rules are rules, but they can always be reinvented. The art of making love cannot have unalterable prescriptions. Lovers can be provided guidance to enhance enjoyment, but cannot be remote-controlled to only perform in certain ways. Vatsyayana repeatedly stresses this point in order not to take away from the spontaneity of the process. A lovers' tryst is a universe of its own. It will find its own galaxy of fulfilment. Once copulation begins, everything is a consequence of passion, arising on the spur of the moment, beyond definition, and beyond 'even the imagination of dreams.' The guru cites the example of a horse, 'which having attained the fifth degree of motion, goes on with blind speed without thought of the holes, ditches and posts in the way.' In the same way do lovers become blind with passion in the heat of the moment. A man should know his own strength and the inclinations of the woman he is making love to. That, and a copy of the *Kama Sutra*, is all that is needed!

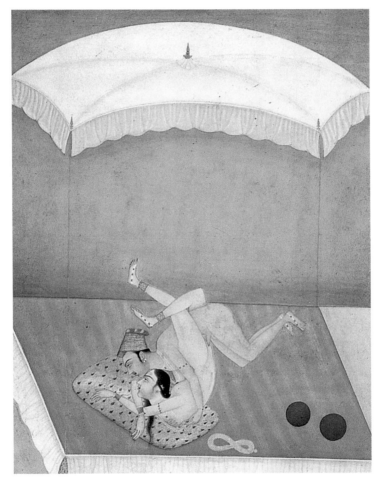

*A woman should only submit to the man who is
sensitive to her needs.*

*Facing page: The woman gradually guides her lover
in the way she likes to be aroused.*

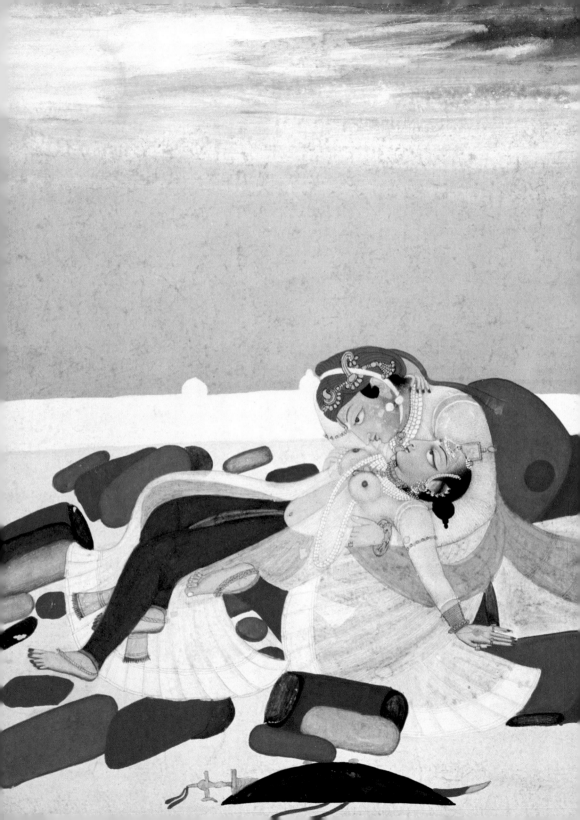

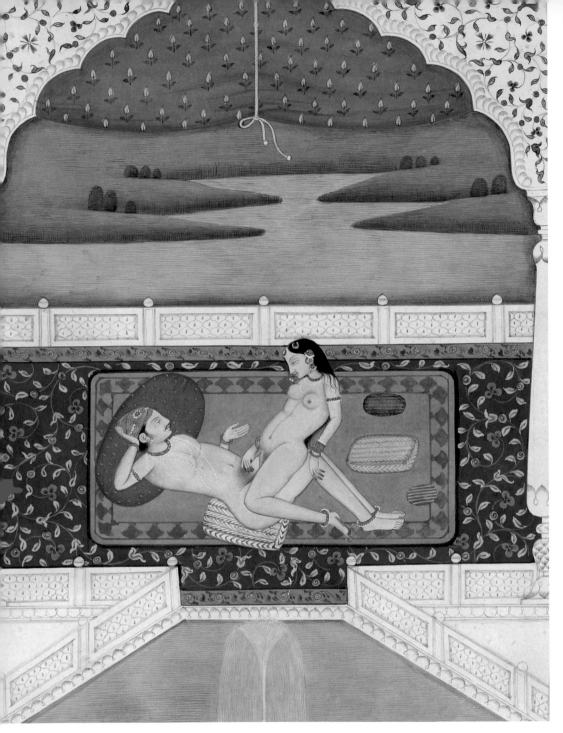

A courtesan knew ways to entice a lover when he started losing interest.

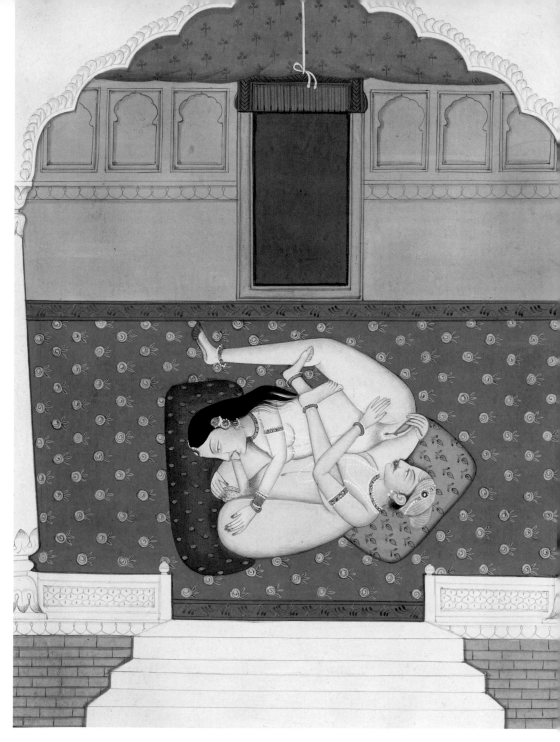

Oral sex is acceptable as long as both partners are willing participants, says Vatsyayana.

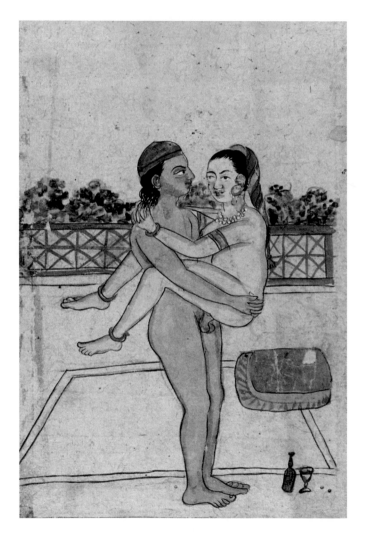

'Suspended congress' requires agility on the part of both partners.

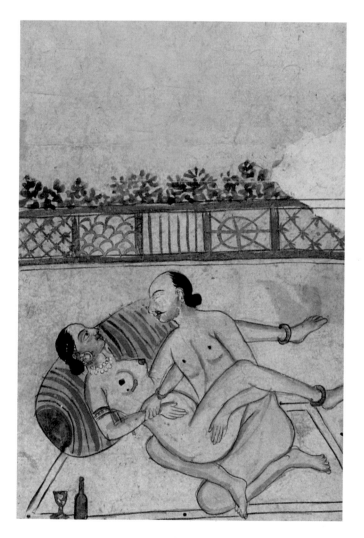

A woman moves her body and limbs to maximise pleasure.

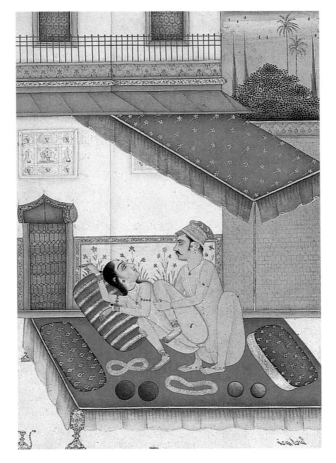

*Perfumed ointments, flowers and garlands, along with
a woman's toiletries such as a pot of collyrium and
a vial of perfume, should be kept within reach.*

*Facing page: Lovemaking should occur only when the bride
and the groom are better acquainted with each other.*

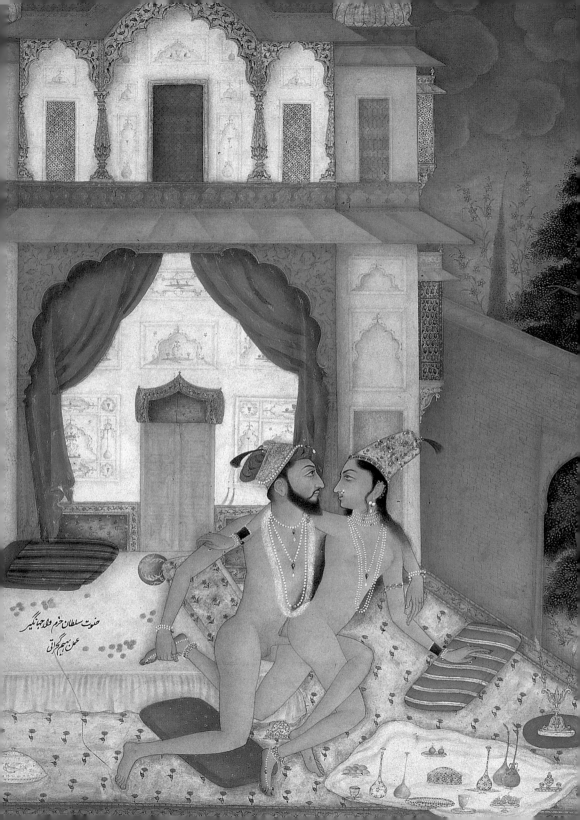

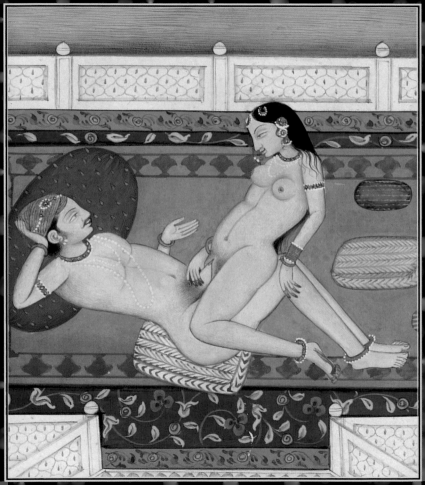

Nothing is
Taboo in Sex

*N*othing is taboo in sex. Well, almost nothing, according to Vatsyayana. Our guru is not a moralist. He cannot understand prudes. Sex is about giving and receiving pleasure. Lovers have to find ways to optimise this experience. Men who have fixed notions of 'right' and 'wrong' constrict the potential of this exchange. The tone of the *Kama Sutra* is matter-of-fact throughout. It makes no moral judgements. Its purpose is to explain the techniques of enhancing pleasure, not to comment on the moral validity of the methods. From this point of view, the squeamish man worships at irrelevant altars. He must jettison his mental blocks, his unnecessary reservations, his misguided inhibitions, and his false conditionings. Only then can he fully enjoy the bliss of sensual fulfilment.

Group sex is all right between consenting lovers, says our guide. A man can enjoy two women, or several women, at the same time, described as the 'congress of a herd of cows,' and a woman can do likewise with

several men. As precedent, Vatsyayana cites the practice in a northern hilly region where several men are married to one woman, and copulate with her either together or in sequence. Similarly, in harems, when the women are lucky enough to get hold of a man, many of them sport with him together. A pool, a lake, or a river provides a good setting for group sex. Sporting of this nature in water is compared to the 'congress of an elephant', for the male elephant is said to enjoy several female elephants while gamboling in the water.

Vatsyayana speaks of oral sex, too. Apparently, there was opposition to this practice during his time. Some people felt that it was a 'low' practice. They also believed that it contravened religious law, and could injure a man should the woman give him a greater mouthful than expected. The guru dismisses such arguments. Displaying a liberality far ahead of his time, he maintained that in matters associated with sex, each person should act according to his own custom, his personal inclination, and the dictates of his judgement. The amount of time available, and the kind of place where the action is to unfold, should also be factors in the final decision.

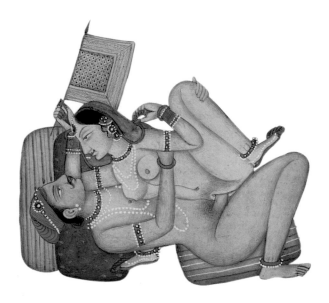

Oral sex is often a very effective way to rejuvenate passion. This is always useful information for a man, but it is not enough for him to be firm and well-informed; if the woman so desires, he must stoop to conquer. The guru specifically cites the *kakila* practice ('sex in the manner of crows'), where the man and the woman both lie down in an inverted position, with the head of the one towards the feet of the other. A man is likely to regain his erection in such an encounter; if he is slow to do so, or if there are genuine problems in achieving and sustaining an erection, he is encouraged to try potions and tonics to increase his vitality. The use of an artificial phallus, or other mechanical devices, is also recommended. There is a word of caution, though. Only those aids should be used which have been found effective after a long trial, cause no physical harm, and do not require the killing of a live animal.

Vatsyayana does not think it wrong for a man to resort to the wives of other men, although he is not a spokesman for licentious behaviour. Someone else's wife is a legitimate pursuit only if his love for her reaches such intense levels that it leads to the loss of mental balance – and even the very will to live. In less dramatic circumstances, a man must carefully weigh the pros and cons: Is she fit for sex? Can she be trusted in her behaviour? What is the future of such a union? How risky is the liaison? What is noteworthy is that our guide is not concerned so much by the morality of the matter, as by the practical consequences of the action. A man does no wrong if he covets another man's wife, but he is foolish if he acts without deliberation. Such pragmatism is as relevant today as it was then.

The guru has advice on how to chase another man's wife. The first step is to create opportunities to meet her. Social occasions, at home or at a third place, provide a good excuse, and should not be missed or wasted. An expression of interest must be quickly conveyed, by looks, gesture, or conversation. Compliments, some subtle, others blatant, should be showered – sometimes directly, at other times to a third person – when she is in listening range. Attention should be devoted to those whom she likes. Pretexts should be found to visit her. Common links should be reinforced.

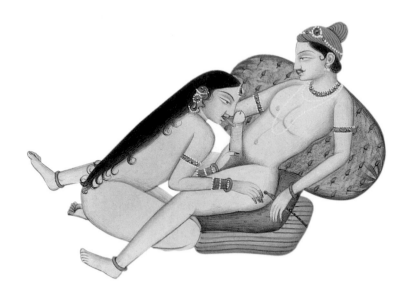

Arrangements should be made for the same goldsmith, jeweller, dyer, basket-maker and washerman to be employed by her family, so as to create reasons to meet with her. An involvement in her business or vocation could create the right alibi for longer visits. If she needs to learn a skill, she should be helped. If she needs money, it should be loaned. Gifts must be given liberally. Finally, when confident that she will reciprocate his feelings, the man should persuade her to accompany him to a secluded place and embrace and kiss her, and touch and press her private parts, thus bringing his plan to a fulfilling fruition.

The desire to bed a married woman may not always require so much effort and planning, though Vatsyayana did not have a one-night stand in mind – often the result of a hormonal surge under the influence of alcohol. His concern was with a relationship that would sustain a more enduring erotic mood, allowing for courtship and dalliance, and an intimacy that could grow by degrees towards an explosive culmination. He seemed to be against abrupt beginnings and ends, conditioned solely by raw sexual appetite. In this sense, the social sanction for a relationship was less

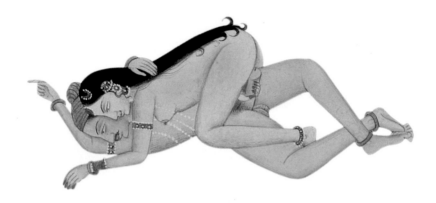

important to him than the manner in which it was structured and consummated. Of course, even an adulterous affair had to be based wholly on the consent of the woman. A man may plan to obtain her consent, but he must never be presumptuous in assuming it. All his stratagems must be directed to her saying 'yes'.

What kind of man succeeds in attracting a married woman? A man who is well versed in the science of love is, of course, at a distinct advantage. But he who speaks well, knows how to win her confidence, possesses an air of innocence, and is good at giving gifts, has a very good chance of succeeding too. Interestingly, good looks and physical strength are placed quite far below in the list of desired attributes. The cultured man with a balanced personality – and not a flamboyant rake, with little else to recommend him except a shallow sang-froid – appears to be the kind of man Vatsyayana would put his money on. Even a courtesan, for whom sex is primarily a source of income, can fall in love, he says, with a man who is learned, sociable, not addicted to his drink, free from anger and envy, well-behaved with the elderly, attracted by women but not besotted by them, and possessed of an independent source of livelihood.

As to what kind of a married woman is available, the list is much longer than that of successful men. Almost every kind of woman is a potential target: young, old, sick, deformed, proud, barren, widowed, abandoned,

rich, poor, lazy, et al. Some descriptions are particularly delectable. Take special note, Vatsyayana says, of the woman who looks sideways at you, who does not like her husband, whose husband travels excessively, who is slighted by her husband without cause, whose husband is inferior in rank or ability, who becomes jealous easily, or who is 'very fond of society.'

One useful nugget of wisdom: a man who desires a woman should also learn to recognise when the woman no longer desires him. Vatsyayana speaks of this in the particular context of a courtesan wishing to get rid of a once-favoured client. However, much of the advice is generally relevant, since men can often be very dumb in understanding a woman when she wants to convey that the relationship is over. Things do not look too good for a lover, says our blunt guide, when the woman does not want to be kissed on the mouth, does not respond to his embraces, lies limp during sex, does not let him touch her between the navel and the thighs, and pretends to be sleepy when he is aroused. Things also do not augur well when she begins to slight him in public, interrupts him when he speaks, is unappreciative of his jokes, deliberately misinterprets him, ridicules his attachment for her, narrates his faults and vices all the time, shows little respect for his vocation or learning, or seeks the company of other men. Amen.

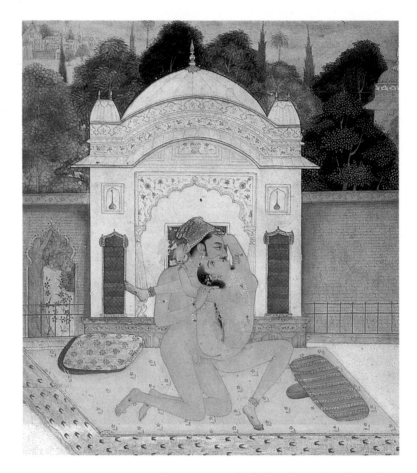

Love grows out of a feeling of mutual understanding.

*Facing page: The woman may place one leg over her
lover's shoulder, while stretching the other one out.*

*Following pages, 188-189: A woman who is fragile
by nature, needs to be wooed with the utmost care.*

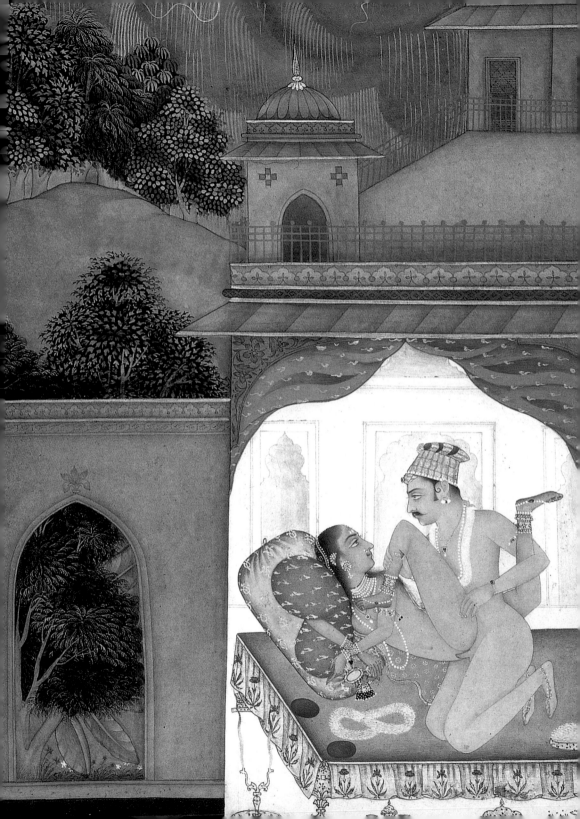

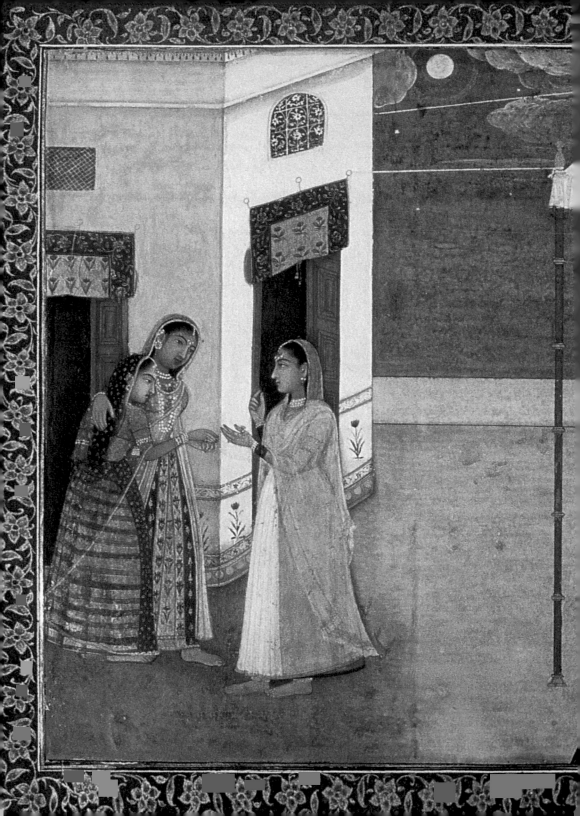

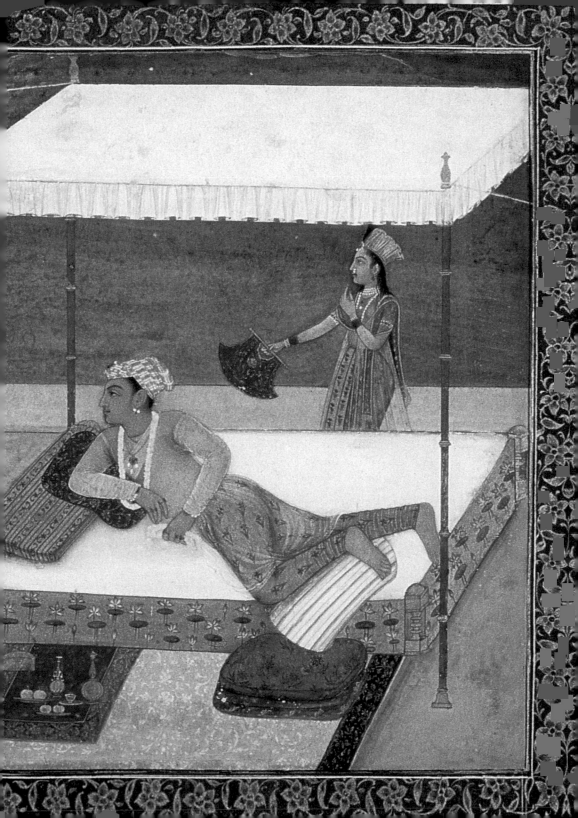

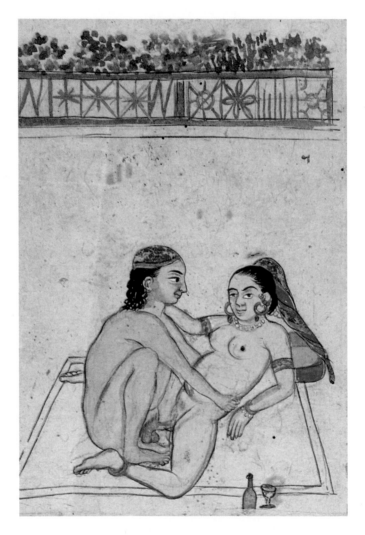

*The purpose of the Kama Sutra is to open lovers to
the myriad possibilities of lovemaking.*

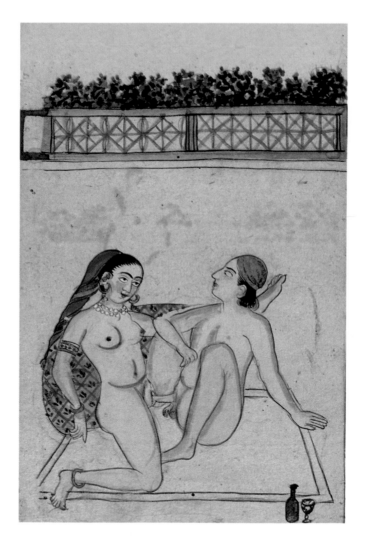

*Vatsyayana gives great importance to the manner in which
a relationship is structured and consummated.*

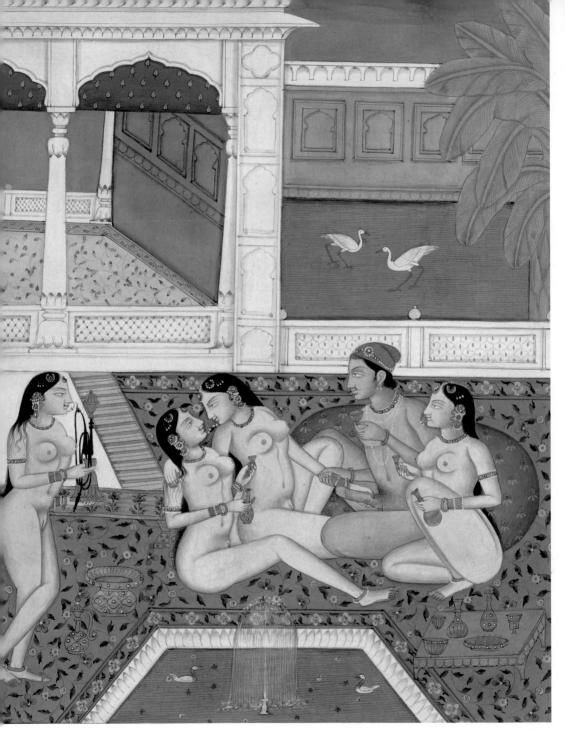

When a man enjoys several women at the same time,
it is called the 'congress of a herd of cows.'

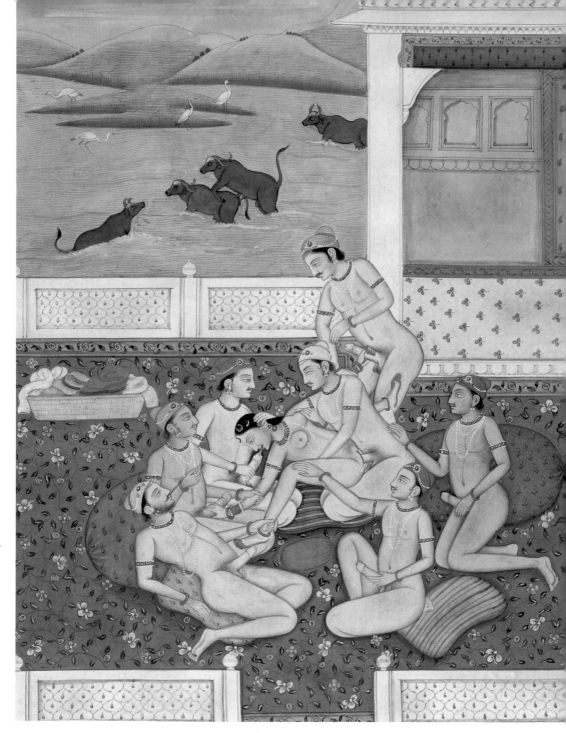

Vatsyayana cites instances of a woman copulating
with several men at the same time.

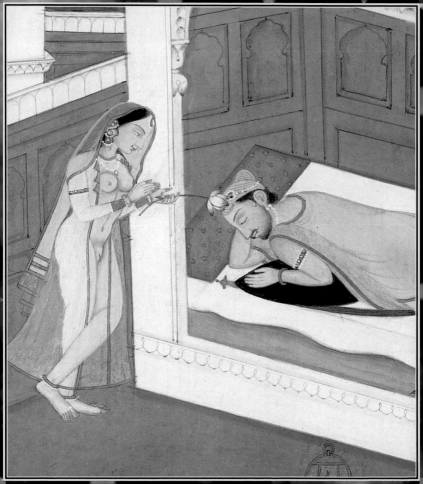

The Ending
of Congress

*N*othing reveals Vatsyayana's respect for women more compellingly than his advice to men on how to bring love-play to a mutually satisfying end. For most men sex ends with their climax. Once it is over they have an overpowering urge to turn over and sleep, or, worse, to turn over and snore. If circumstances do not allow for the luxury of sleep, they want to pull up their pants and run. The guru has no patience with such boors. A good lover must have the refinement to bring physical intimacy to an aesthetic finale. He must invest in the creation of a post-coital mood that imparts respect to the woman, allowing the sensuality of the experience to find new expression in an ambience of sharing and togetherness.

The inert silence that descends when the spontaneous tumult of passion recedes, can have its awkward moments. These must be handled with tenderness and confidence. Once love-play ends, a man should have the courtesy to give the woman (should she indicate the need) the private space to visit the washroom by herself. On her return, he should make her feel welcome and wanted; for otherwise, she will only be confirmed in her

suspicion that the sex was more important than she was. He should offer her betel leaves, or perhaps its more accessible equivalent today, a cigarette, if she smokes. A massage that drains away the fatigue of her physical exertions would be received very well. Sandalwood paste is the guru's favourite, but he concedes that any other fragrant oil will do as well. As she relaxes, he should embrace her again and persuade her to drink from a glass held in his own hand. She may like to nibble something along with it: fruits, cold cuts, grilled morsels and sweetmeats would be perfect. The courtesy and concern should be sustained. If she is not eating, he should coax her to do so with words such as: 'this is sweet,' or 'this is really nice,' or 'this is worth trying.' Later, if she is in the mood, he should guide her to the rooftop or the terrace to watch the moon and the stars. As she sits on his lap, he should point out the different constellations and, in general, conduct a conversation agreeable to her.

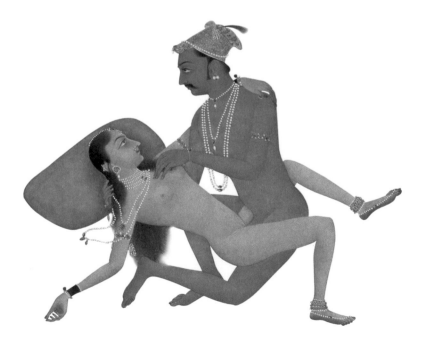

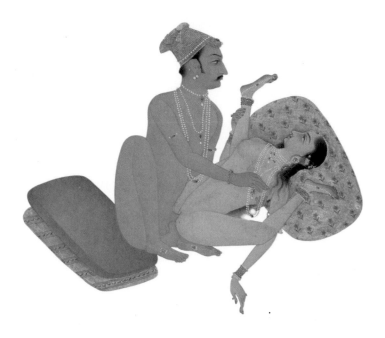

One might wonder why Vatsyayana wants men to be so gallant even when they may not be upright. The nature of the relationship does not concern him. Lovers could be husband and wife, friends, acquaintances, or even strangers. Their union could be sanctioned by society, or it could be clandestine. The circumstances are unimportant. The fact is that he is implacably opposed to the school of thought that treats women solely as sexual objects. A good lover must have the capacity to structure a sensual odyssey that begins well and ends on an even better note. He must believe that anything so beautiful cannot have an abrupt or soulless ending. He must feel the need to pay homage to a partner who has the potential of being the source of so much joy. Obviously, not every sexual engagement can have such a refined or elaborate ending. The moon is not resplendent every night. The stars are not always visible. Not every encounter allows for an unhurried massage after the event. The scenario the master portrays is not meant for blind emulation. Its purpose is to indicate the approach that should mark the end of love-play. Its aim is to stress that a man should, in

whatever manner possible, demonstrate his ability to be considerate and romantic after congress ends. A man who leaves the bed after he has climaxed, devalues the experience he has been part of and demeans the woman who has made it possible.

The issue here is not only of correct behaviour. Vatsyayana genuinely believes that the post-coital cocoon of relaxed intimacy created by the thoughtful man can be a unique source of pleasure. After the surge of passion, serenity brought about by a sense of fulfilment provides just the right setting for quiet conversation. It could be an occasion for lovers to ruminate about each other, and to talk again about how they met, what happened next, and how their love for each other grew. Even if the relationship is not one of enduring love, the creation of an atmosphere of serenity and harmony at the end of sexual agitation is a benediction valued by sensitive lovers, and is especially important to women.

Of course, the right post-coital ambience is also the best nursery for desire to germinate again. The guru knew that in the quality of the lull lies the hope of a recurring storm. In making a woman feel wanted and loved after making love to her, the intelligent man is only investing in the possibility of an even more fulfilling encore. And so the wheel of passion turns. But through its ceaseless flux, its many ups and downs, the teachings of *Mahamuni* Vatsyayana remain constant in their promise of the pleasure of the senses. A man who imbibes their wisdom can forever enjoy the garden of love, a garden so perennially joyful that it could only have been bequeathed to us by the gods.

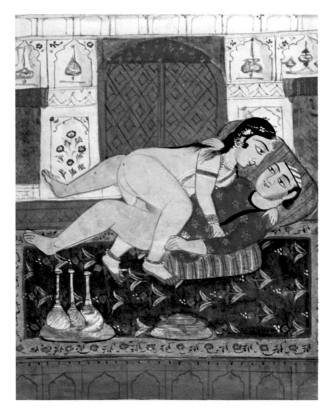

Reciprocity is essential for a healthy and satisfying relationship.

Facing page: *Group sex, though not common, was not unknown.*

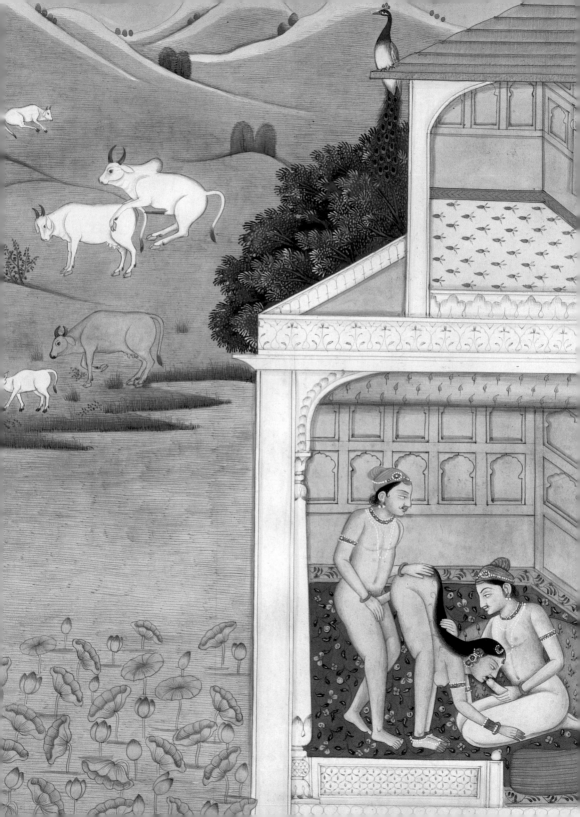

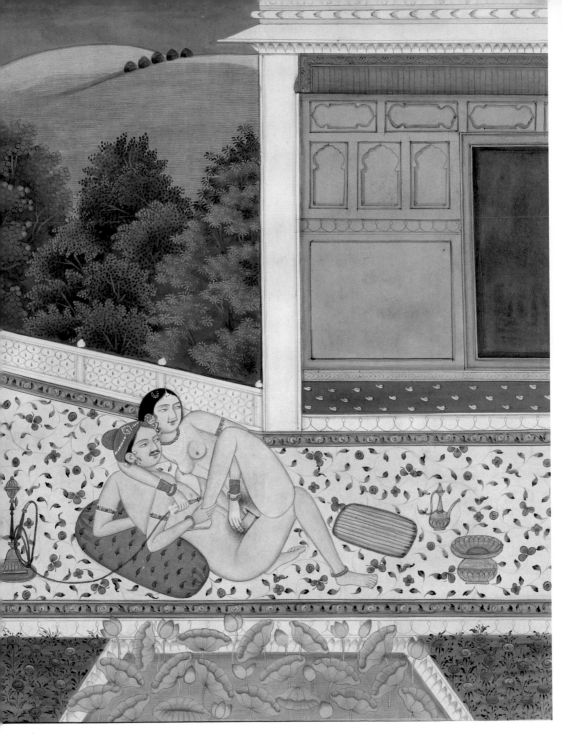

The ancients were known to drink love potions to improve their performance—and bring greater pleasure to their lovers.

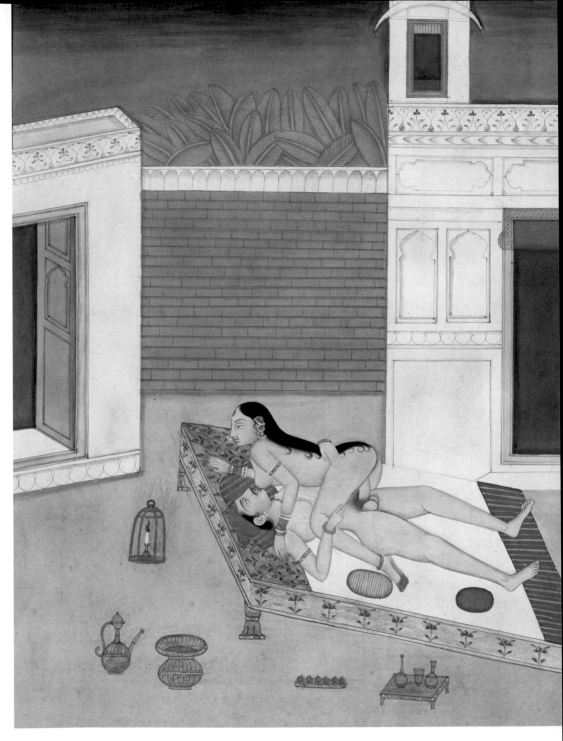

Every woman is unique and must be treated with respect.

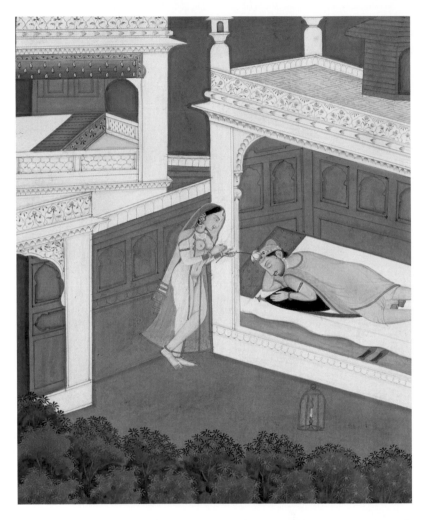

The man must resist the urge to sleep post-coition. Instead, he should embrace his beloved and make her feel desirable.

Facing page: Once the man has sensed the woman's interest, he should take her to a secluded spot for a time of solitude.

Following pages, 206-207: Touching, biting and scratching are all permissible in the act of love.

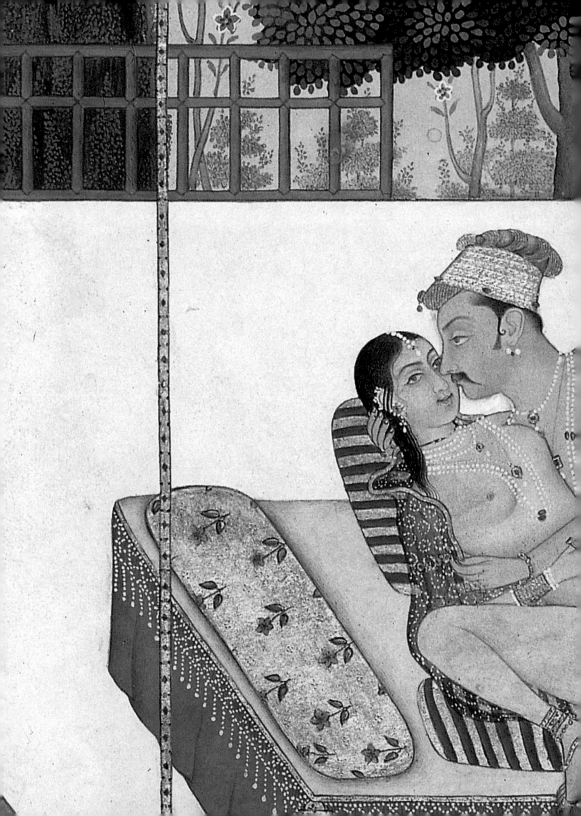

Photo Credits